The Christmas Story

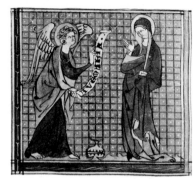

THE CHRISTMAS STORY
in Medieval and Renaissance Manuscripts from the Spencer Collection

BY KARL KUP

The New York Public Library: 1969

SPENCER PUBLICATION FUND

Publication Number One

Library of Congress Catalog Card Number: 70–98680
Copyright © 1969 by The New York Public Library
Astor, Lenox and Tilden Foundations

Standard Book Number: 87104–053–0

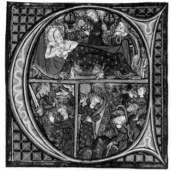 ANTATE DOMINO CANTICUM NOVUM: QUIA MIRABILIA FECIT, reads the ninety-eighth psalm, here introduced by a large and illuminated initial letter from a medieval English manuscript with miniature paintings relating to the Christmas story from the Spencer Collection of The New York Public Library. The Spencer Collection was created by the bequest of William Augustus Spencer who had lived in New York and Paris where he had collected finely illustrated French books in fine bindings of his time, from 1880 to 1910. His bequest to the Library included not only 232 handsome books of his own, and so a personal collection, but also a generous endowment fund, together with a most perspicacious and promising direction: "that the income from the endowment is to be spent for the purchase of the finest illustrated books and manuscripts that can be procured of any country, and in any language, and of any period." These books, so Mr Spencer suggested, might well represent the arts of illustration and binding throughout the centuries. Thanks to this generosity and vision, the Spencer Collection now contains several thousand books and manuscripts, from many lands the world around.

From the nearly two hundred illuminated and illustrated medieval and renaissance manuscripts, a selection has been made to illustrate the timeless Christmas story. As we know it best, this traditional story is made up of the Annunciation, the Nativity, and the Adoration of the Magi. But the story has its beginnings in Old Testament prophecies and in the scenes from the life of the Virgin. Its spiritual significance is deep in the literature of the Scriptures. Illuminated manuscripts of the Bible, Breviary, Book of Hours, Missal, and Lectionary contain innumerable miniatures telling the Christmas story: naively, symbolically, realistically. They recall to us not only the artistry but, above all, the faith, the devotion, and the delight of their makers: "Sing unto the Lord a new song: for he hath done marvellous things."

Part One:

The Prophecies

The Three Angels Appearing to Abraham

1

RUDOLF VON EMS: WELTCHRONIK

MANUSCRIPT IN GERMAN ON PAPER / GERMANY, 1402

And the Lord appeared unto him in the plains of Mamre: and he sat in the tent door in the heat of the day; And he lift up his eyes and looked, and, lo, three men stood by him: and when he saw them, he ran to meet them from the tent door, and bowed himself toward the ground, And said, My Lord, if now I have found favour in sight, pass not away, I pray thee, from thy servant. — Genesis 18:1–3

Abraham, the "exalted father," is perhaps best known for the goodness of his character, his intimacy with God, and his spiritual fatherhood of man. He had marched across the ancient world from the Euphrates to the Nile, he had undergone trials and tribulations, a first born was denied him. For his faith, the Christian Church recognized in Abraham a spiritual ancestor; because when the three angels of the Lord came to call he offered them hospitality, eagerly awaited a message, and was rewarded in the end. In byzantine times the three angels represented the Holy Trinity, in the typology of the medieval Western Church the announcement of the birth of Isaac by the angels prefigures the annunciation to the Virgin of the birth of Christ.

The pen and ink drawing in the German manuscript of 1402 represents the appearance of the angels, Abraham's name is neatly written above the entrance to his "tent," and the drawing emphasizes the element of surprise, of tidings to come. Rudolf von Ems's *Weltchronik*, based on Old Testament stories, was composed in the earlier part of the thirteenth century when the author, living at the court of Simon de Montfort, seemed to have leisure to write and compose — in the spirit of the times — versified popular histories of Alexander, Josaphat and Barlaam, and the World Chronicle shown here. The manuscript, one of about eighty of this text to have come down to us, most of them of the fifteenth century, contains 287 colored sketches full of liveliness, spontaneity, and story-telling impact. In its joyfulness this visitation ushers in the Christmas story.

die noch man gewinne nie
die nempt vnd habt sie
daz man geste plaibn ir
des grozzen mayles vnd auch ich
des lat euch erpete mich
hinrich ew sarhchante gir
nicht tut si groz last mir
Es warte si vil chlain
si drunge all gemain
vnd wolte auff prechn dy tur
do si chome warn do fur

gesunt vnd lemptig bewarn
dy haus mit din hinnan varn
daz in leydes icht geschech
vnd hut daz si icht vmbe sech
do chames auff den leyp
Es sey man od weyp
daz mit dir in dem schar
welle varn vnd mit var
daz es ich chom in werende not
Av het pey den zeite lot
gelobt zwain chnabn
von der stat
dem weist do er dy par
vnd in riet daz si
mit in dan
stirn dy selbn zwe man
achte clain d gerschicht
vnd varn mit im nicht
got d gut rain man
hub sich auf vnd schied vo dan
des morges do es tage
vil pald fur sich uz ge
Chind vnd weyb do
wart zehant
vo himel auf dy stat gesat
prinnendes pech vn swebel
vnd ein brinend nebel
ayt ein dikchen hagel groz
Stet vnd lant so sere begoz
daz si an den stundn
zer fliezzn gar begundn
vnd gein dem apgrunde sich
rich sich ir werte strich
Also daz do zehant
daz apgrunde si uslant

vnd wolte han geprochn in
in wart betaubet so d sin
daz si zer selbn stundn
die tur nie vinden chundn
vnd wa daz haus war gesat
die tumben so von d stat
schieden vo dem haus dan
zu lott vil guter man
sprachn dy engl do hast du
iemant den du wellest nu

Abraham Serving the Three Angels

2 THE GOSPEL ACCORDING TO SAINT LUKE

MANUSCRIPT IN CHURCH SLAVONIC ON PAPER /
RUSSIA, 15TH CENTURY

Let a little water, I pray you, be fetched, and wash your feet, and rest yourselves under the tree: And I will fetch a morsel of bread, and comfort ye your hearts; And Abraham hastened into the tent unto Sarah, and said, Make ready quickly three measures of fine meal, knead it, and make cakes upon the hearth. — Genesis 18:4–6

Sarah rushed to the larder, a calf, tender and good, was fetched, dressed with butter and milk, and was set before the visitors seated around the table. Abraham stood by them under the tree, and they did eat. And when they had partaken of Abraham's hospitality they said: "and, lo, Sarah thy wife shall have a son."

The miniature in the Slavonic manuscript shows, ikon-like, the feast, the guests, the hosts. Abraham holds a pitcher, Sarah the plate of cakes; a chapel is in the background, and a little ghost of a tree gives them shelter from the heat of the desert. The angels sit rigidly, with byzantine stringency of movement. The central angel, with wings outspread, is larger, more majestic, than his companion. In the view taken by the fathers of the Eastern Church he represents a vision of the pre-existence of Christ.

The Gospel according to Saint Luke, from the Spencer Collection, is written in Church Slavonic dating from the early fifteenth century. The placing of this familiar Old Testament scene as an illustration to the Gospel emphasizes its prophetic prefiguration of the coming of Christ.

н є сшоу жє с лоу вн н павлоу · въ ровавшоу въı тн є
шєствнан послѣдоватєлꙗ тому · гла павлоу ·
ноу во с ҃пнса в єꙋлiє с · въ с ҃ ı кнꙗ з въ стєпко ·
ꙗ · тожє нсамоєто начало сꙋвꙗвлꙗєтꙉ · по ⷨ
на дє сꙗ тн на ⷮ х ҃ва възнєсєнiꙗ · пншєтжє ·
къ ѳєꙋфнлоу єн снꙗ нтнноу єжщоу нєн на ꙋ
оу во · єжєбє дрьжавнын · нꙗ на на вєнгємꙃ
нтьрꙑ глаашєсꙗ · н павєлъ рєꙋ нгєꙗ лꙃноу
фiстоу · дрьжавнын фiстє · н вѣⷮ нжєло
въ ı къ в ҃голюбнвын · дрьжавꙃ на страстн ⷩ
въ сєпрнє · ѳєꙋфнль є ҃стъ дрьжавнын · с ҃прь ⷮ
в ҃голюбєцъ · нжє
доннь є ҃стъ по
нстнн ⷩ слꙑ
ша
тн
с ҃тго
єꙋлiоу

3 DE LA TWYERE PSALTER

MANUSCRIPT IN LATIN ON VELLUM / ENGLAND, YORKSHIRE, CA1320

And he said, Take now thy son, thine only son Isaac, whom thou lovest, and get thee into the land of Moriah; and offer him there for a burnt offering upon one of the mountains which I will tell thee of. . . . And Abraham stretched forth his hand, and took the knife to slay his son. And the angel of the Lord called unto him out of heaven. . . . And he said, Lay not thine hand upon the lad, neither do thou anything unto him. — Genesis 22:2–12

One of the many Old Testament prophecies foretelling the coming of Christ is the sacrifice of Isaac regarded as the prototype of Christ in his obedience to God. The miniature within the initial letter of the manuscript combines three illustrations of prophetic and symbolic significance. The sacrifice shows the hand of God saving Isaac at the decisive moment; the Nativity presents a cozy, domestic scene in the stable with Mary happily reclining, Joseph at her bedside, and both adoring the Child in the arms of a nurse. Ox and ass enjoy their trough of fodder; two hanging bowls give warmth and light. The third scene shows the annunciation to the shepherds with a gracious angel pointing to the star of Bethlehem, symbol of the birth, and holding a palm leaf in his hand, symbol of peace. One of the shepherds in traditional medieval garb is blowing a ram's horn, conveying the glad message to others in the field and to the world at large. The initial letter "C" begins the ninety-eighth psalm *Cantate domino canticum novum* — O sing unto the Lord a new song.

The manuscript, called the De la Twyere Psalter, was written in Yorkshire for the De la Twyere family about the year 1320. Saint Hylda of Whitby and Saint Everilda, both local saints in Yorkshire, are among those invoking the Virgin, in the text. And a notation on one of the calendar leaves records the death of William De la Twyere, patron of the Saint Sepulchre Hospital at Preston in Holdernesse, founded by members of the family.

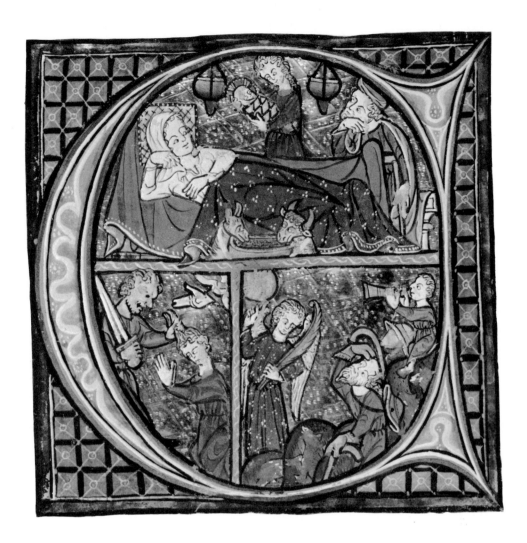

 LIBER GENESIS

MANUSCRIPT IN GERMAN ON PAPER /
GERMANY, CA 1470

And Abraham lifted up his eyes, and looked, and behold, behind him a ram caught in a thicket by his horns: and Abraham went and took the ram, and offered him up for a burnt offering in the stead of his son. — Genesis 22:13

Abraham's offering of Isaac, the crowning test of faith, taught the need of consummate sacrifice for the final ratification of the covenant. But it also furnished the early Church fathers with a model of perfect submission to the will of God, even in the severest trials. The ram that is finally killed signifies the humanity, and Isaac who remains alive the divinity of God. In medieval times the sacrifice became one of the most beloved subjects for the mystery plays performed in churches, before church portals, or on wheeled stages in the market place. Here the Old Testament stories were versified, popularized, made palatable for the common man and his devotions; they were usually played by the guilds and trades. The "Sacrifice of Isaac" is one of the cycle of the "Histories of Lot and Abraham," played in Chester and acted by the Barbers and Wax Chandlers some time during the latter part of the fourteenth century. God, Abraham, Isaac, and the Expositor are the actors: Isaac pleads for his young life, Abraham assures him of God's will, of his possible mercy: "Dreede thee not, my childe, I reade; Our Lorde will sende of his godheade. Some manner of beaste into this steade, Either tame or wilde."

The ram caught in the thicket and the angel of the Lord soaring from heaven and literally taking hold of the obedient sword make but one of the fifty-seven pen and ink sketches — lightly colored, crude perhaps, but popular and arresting in their immediate, literal rendition of the Bible tale — which illustrate this manuscript of the Book of Genesis, written by an unknown hand in Southern Germany not much later than 1470.

braham sprach zu dem chind sin
nu gee wir an dy stat dy vns got
gepot Also nam er das holz des
opphers vnd legt es auff seinen sun ysaac
vnd hyes in das tragen Er selber trueg das
fewr vnd ain swert vnd do sy mit ainander
giengen Do sprach das chind ysaac zu dem
vater mein vater Der vater antwurt was
wil du mein sun ysaac sprach Hym war
fewr vnd holz sind hye wo ist aber das
opher Do sprach abraham Got fürsiht
vns des opphers Also giengen sy vntz an
dy stat dy im got het gezaigt do er sein
sun ysaac solt opphern Do macht abraham
ain altar vnd legt dar vnter fewr vnd
holz Hye schreibt josephus dy wort
dy abraham mit seinem sun redt Nach sein
redt als dy welt von gottes willen ist
ausgegangen wunderleich von nicht Also
ist es auch ain nottürst wann got ainen
menschen wil nemen von der welt ain
slechtumb an streit vnd an alles leyden das
den menschen an get Das der also nach
gottes willen verstand vnd steet selber
got erbeyt zu ainem oppher Also gieng ysa-
ar williglich zu dem tod Do hieng abra-
ham vnd nam das swert vnd wolt den sun
opphern wann er het gantzen gelauben
zu der vrstend Do rust der engel abra-
ham vnd sprach abraham abraham Do
antwurt ich pin hie Der engel sprach
Nicht streckh dein hant vber das chind vn
tue im auch nicht laides wann got erkennt
mit das du in fürchst vnd hast nicht geschont
deines ainigen suns durch in wann got
maint ysaac tod nicht Er wolt allain hai-
gen das man west wy hart abraham got
forcht Do hueb abraham sein augen auff
vnd sah hinder im ain wider mit dem ge-
hiren in der stauden hassten Den opher er

got für sein sun vnd nemt dy stat der herr
hat es gesehen Darvmb haist der perg
vns auff den hewtigen tag Der herre hat
es gesehen da von halten dy iuden also wan
sy in truebsal sein noch ein sprich wort
Got wirt sehen auff den perg verirt als sy
sprechen als got erhörrt ysaac auff dem
perg Als erhöm auch vns in dem truebsal
vnd erledig vns Dy iuden sprechen das
ysaac an dem ersten tag des sibenten mo-
naids erledigt sey Darvmb pegern sy noch
dy hochzeit an dem tag vnd plosent mit
horen Darnach rust der engel an der stund
abraham vnd sprach Er spricht der herr
pey mir selbs hab ich gesworen darvmb
das du das ding hast getan vnd hast dei-
nem ainigen sun nicht vber sehen durch
meinen willen Dar vmb gesegen ich dich
vnd manigvelt deinen samen als dy stern
des hymels vnd als des meres gries den
sun sol pesitzen dy porten irer veind vnd
in deinem namen werden gesetzet alle
geslecht der erdem wann du pist gehorsam
gewesen meiner stim Do cheret abraham
wider zu seinen chnechten Do er sy vol-
lie vnd ziengen mit ain ander ger beysabe
vnd waren wonhaft da etc ¶

Hye hort von nachor abrahams prud-

5 BIBLIA PAUPERUM

MANUSCRIPT IN GERMAN ON VELLUM /
GERMANY, CA 1420

And the angel of the Lord appeared unto him in a flame of fire out of the midst of a bush: and he looked, and, behold, the bush burned with fire, and the bush was not consumed. — Exodus 3:2

Saint Augustine's saying, *novum testamentum in vetere latet,* becomes more understandable when one regards a Biblia Pauperum in which scenes from the Old and the New Testaments are paired to show how the messiah's coming was foretold. Developed from biblical cycles in mural, enamel, or stained glass, this typological text was never the work of one man; it had grown out of the teaching of theological scholars, and its full cycle had later been painted and illustrated by anonymous medieval artists and scribes. Over the years the Biblia Pauperum became a convenient concordance for those teaching, preparing sermons, or merely studying. And its name, the Bible of the Poor, indicates that it may have been meant for the poorer mendicant who had not the money to acquire so expensive a work as a complete Bible.

Both Moses and Aaron, here on either side of the Nativity, prefigure the Immaculate Conception: Moses in his vision of the angel of the Lord in the bush that "was not consumed," a bush which can be seen to this day growing within the monastery walls on Mount Sinai, and Aaron, here in medieval costume, whose rod "brought forth buds, and bloomed blossoms, and yielded almonds." The manuscript's thirty-eight full-page drawings are all similarly arranged: the New Testament fulfilment is flanked on either side by an Old Testament prophecy; the whole surrounded by four portraits of prophets within circles, such as Elijah, Isaiah, and Ezekiel. The manuscript, written in a Bavarian dialect, was illustrated in Southern Germany in about 1420.

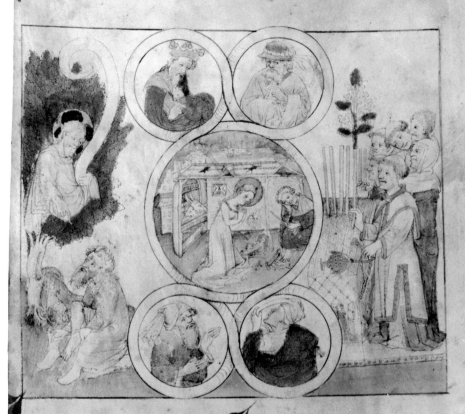

In dem Buch Exodi an dem Critte
Capitel Das moyses sach Brynne
ainen Busch der doch nit verbran
vnd hort das der herr vss dem busch
zu im rett Der Busch der da bry
net vnd nit verzert bedütet
vns das ain Junckfrow ain kindlin
solt geberen ain mönschlichen sámen
vnd doch Junckfrow solt belyben das
ist beschehen wen si Junckfrow be
leben ist vor der gebürt in der gebürt
vnd auch nach gebürt ❡ ·· ··

In dem Buch der Zal In dem sy
bentzehenden Capitel List man daz
die gert Aaron vss ain nacht blüent
ward die was dürr vnd bracht man
del Das bedütet die Junckfrowen die
gottes sun geberen solt an mönsliche
sámen ❡ ❡ ·· ··

6 ISHAQ IBN IBRAHIM: TALES OF THE PROPHETS

MANUSCRIPT IN PERSIAN ON PAPER / PERSIA, SAFAVID PERIOD, 1577

And Moses and Aaron went in unto Pharaoh and they did so as the Lord had commanded: and Aaron cast down his rod before Pharaoh, and before his servants, and it became a serpent. Then Pharaoh also called his wise men and the sorcerers they cast down every man his rod, and they became serpents: but Aaron's rod swallowed up their rods. — Exodus 7:10–12

The Moses who was to become the leader of his people had the confidence and the trust in his God, as he had in his people, to free them from Pharaoh's bondage and lead them to the promised land. In this role, Moses was seen by the early Christian Church as the prototype of Christ as the messiah. The Bible relates a miraculous and arresting incident in Moses's effort to persuade, to threaten, Pharaoh to let his people go. The dramatic tale of "the rod of Aaron" turning into a serpent of terrific appearance and gigantic dimensions, which swallowed the serpents produced by the rod of Pharaoh, including "wise men and the sorcerers," presents a symbol of the power of faith and conviction.

In the world of Islam, and recorded in the Koran, many of the Old and New Testament great have been accepted as "prophets." Abraham, Isaac, Joseph, David, and Christ himself are included. In accordance with the established Islamic tradition of Muslim theologians who condemned all forms of representational art, Ishaq ibn Ibrahim's "Tales of the Prophets," a compilation of miracles and marvels composed in the twelfth century, was not illustrated at first. Later, as the "Tales of the Prophets" came to be considered history, the most imaginative, delightful, and colorful illustrations began to glow from the pages of many such "worldly" manuscripts. Islamic illustrative art, ironically inspired by the rival and Christian faith, had arrived.

The miniature from a Persian manuscript of 1577 relates in radiant color the tale of Moses' faith and follows the text of Exodus almost literally. There is Pharaoh, there are Moses and Aaron, the servants, the serpents. Moses' serpent has become a dragon of the fiercest kind, and the Persian text states that it "swallowed seven thousand men and then approached the throne of Pharaoh who begged for mercy." The manuscript, possibly written in Isphahan, contains eighteen equally entertaining miniatures.

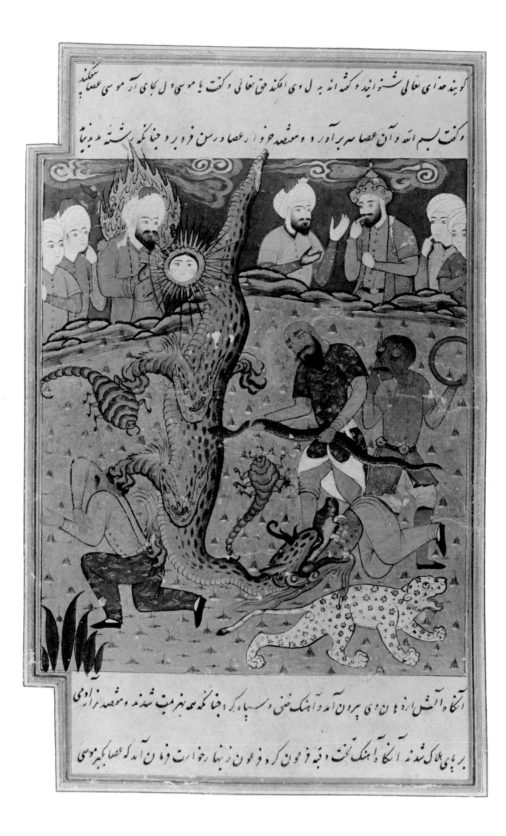

Elijah in the Fiery Chariot

7 BIBLE HISTORIÉE ET VIES DES SAINTS

MANUSCRIPT IN FRENCH AND LATIN ON VELLUM /
FRANCE, CA1300

And it came to pass, when the Lord would take up Elijah into heaven by a whirlwind, that Elijah went with Elisha from Gilgal. . . . And it came to pass, as they still went on, and talked, that, behold, there appeared a chariot of fire, and horses of fire, and parted them both asunder; and Elijah went up by a whirlwind into heaven. — II Kings 2:1–11

Next to Moses, Elijah is the greatest of all of the Old Testament figures. His uncompromising effort on behalf of moral right and social justice paved the way for the later development of ethical monotheism. Opposing King Ahab and Jezebel's Canaanite and Phoenician cult of Baal, Elijah withdrew into the desert where, by the brook Cherith before the Jordan, he was fed by a raven. Called by a voice to come forth from the cave, he went to the top of the mount. After a storm that tore down mountains and opened valleys, he heard the voice of God, smooth and calm: "return on the way to the wilderness of Damascus." And Elijah, simple, fearless, and stern, went and righted the destiny of the people and thus became the preserver of Israel's distinctiveness.

Since both Moses and Elijah had been in the presence of God, they appear in early Christian iconography in representations of the Transfiguration; by his miraculous ascent into heaven, Elijah prefigures the Ascension of Christ.

The miniature, set against a background of traditional diaper pattern, tells most eloquently of God's calling Elijah to heaven, together with the "chariot of fire, and horses of fire." Hands raised in anticipation of heavenly shelter, Elijah leaves the worldly world and his chosen successor, Elisha, in wondrous awe; and the latter takes the mantle "that fell from Elijah." The miniature is part of a manuscript of stories from the Old and New Testaments which also recounts the lives and miracles of the apostles, saints, and martyrs; these stories and lives are presented in 846 miniatures accompanied by a text in French and Latin. The manuscript was written in the North of France, possibly Rouen, in the year 1300.

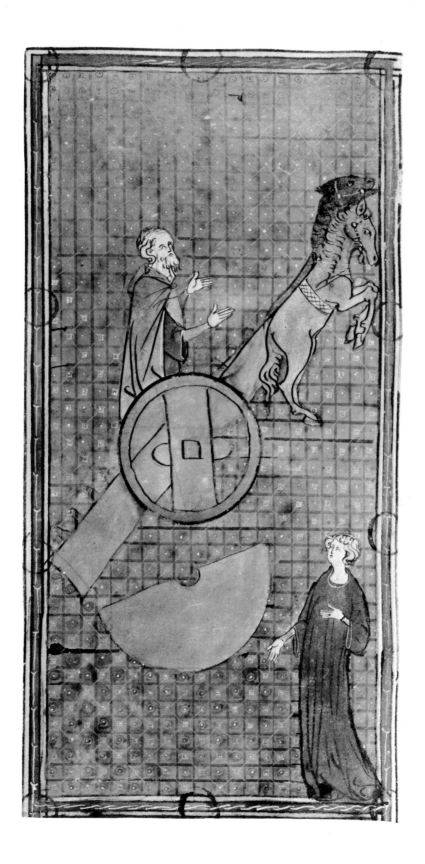

8 PSALTERIUM

MANUSCRIPT IN LATIN ON VELLUM / GERMANY,
BAVARIA, 12TH CENTURY

Why boastest thou thyself in mischief, O mighty man? The goodness of God endureth continually. Thy tongue deviseth mischiefs; like a sharp razor, working deceitfully. — Book of Psalms 52:1–2

The Book of Psalms is commonly attributed to David, an authorship that was upheld by the early Latin fathers but opposed by Saint Jerome. It is a compilation of one hundred and fifty songs to be accompanied by string music. Called the songs of praise, they form a commentary upon the one thousand years of history of Israel and, in part, look forward to the coming of a messiah. Indeed, the aspirations of the Psalmist seem to concentrate on this expectation. Whenever evil men appear about whom the Psalmist frequently complains as in the above quotation, they are represented as sorcerers, so that the psalms turn into countercharms, foretelling the coming of the Son of God! The Psalter is essentially a liturgical book, and is often called the hymnal of the second temple. In the Christian Church the Psalter was usually the first book given a convert; its beauty and its poetry made it a splendid book for prayer and devotion.

The Psalter was also the most often illustrated liturgical book of the Christian Church. Versions of splendid cycles of illumination exist from the earliest time, and the variety of subject matter drawn from the Bible points up the imagination fostered by the psalms themselves. *Quid gloriaris in malitia qui potens es in iniquitate? Tota die injustitiam cogitavit lingua tua,* reads the opening passage of Psalm 52 reproduced here and quoted in English above. This is one of the more plaintive songs but it ends in a joyful and elated feeling of emergence from depression into hope.

The manuscript is a small codex of 152 vellum leaves with six miniatures and many initial letters, strong, decisive, full of character. Its scribe might have been a Carthusian monk from the monastery of Buxheim in Bavaria; its illuminator an artist from the Upper Rhine region. Both hand and miniature indicate the twelfth century.

GLORIARIS

ly q̃ malicia · qui potens
es in iniquitate: Tota die iniusticiã
cogitauit lingua tua · sic nouacula acu
ta fecisti dolum · Dilexisti maliciam
sup benignitatẽ · iniquitatẽ magis q̃m
loqui equitatem · Dilexisti omīa uer

Psalm LXIX, A Psalm of David

9 LES HEURES DE BLANCHE DE FRANCE

MANUSCRIPT IN LATIN AND FRENCH ON VELLUM /
FRANCE, PARIS, 1350–1360

*Save me, O God; for the waters are come in unto my soul. I sink in deep mire,
where there is no standing: I am come into deep waters, where the floods
overflow me. I am weary of my crying: my throat is dried: mine eyes fail
while I wait for my God.* — Book of Psalms 69:1–3

David pleading to the Lord for deliverance prefigures Christ in his agony.
The Psalter is filled with allusions to the coming of a messiah, to quote
Bossuet: "David saw the messiah from far, far away and he sang in his many
psalms with an incomparable magnificence. '*Salvum me fac, Deus, quoniam
intraverunt aquae usque ad animam meam,* the waters have come into my soul!' "
 The manuscript is a splendid example of innumerable prayer books and
psalters for which fourteenth-century France is responsible. Not only did the
scribe do himself honor in the quality of his hand, but the miniaturist, a true
representative of the artists of the Ile de France, rendered some of the
more illustrative scenes touchingly, imaginatively, and beautifully. The large
initial letter "S" is here divided into two sections: Christ bends his head slightly,
listening, understanding, and holding up his hand, the sign of acceptance, of
grace; David, below *usque ad animam* in deep waters, raises his hands in
supplication — he is nude except for his crown, sign of his royal stature.
Les Heures de Blanche de France, a prayer book which contains many psalms,
has several similar scenes telling of the coming of Christ.
 The manuscript was written for Blanche de France, daughter of Charles
le Bel, who lived from 1328 to 1370. In 1345 she married Philippe d'Orléans.
The daughter of a king and of Jeanne d'Evreux, a queen, she often appears
in the miniatures of the manuscript as a donor in prayer, before the Madonna,
participating in divine services. She is always depicted as small, slim, graceful,
and appealing yet of great style and personality.

nubibus. Mirabilis
deus in sanctis suis de
us isrl̄: ipē dabit virtu
tem et fortitudinē ple
bis sue benedictus dn̄s.

Dominatoꝛ. Oꝛo.
domine qui in
stis spirituale epulū
tribuens sacis eos inle
ticia delectare. concede
quesumus gregi tuo
mortem tuam intelli
gere. atꝗ triumphato
rem mortis sedentem
ad dexteram patris co
siteri. Qui tecum vi
uit et regnat deus. p
omnia secula seculo
rum. amen psalmus
dauid.

al
uu
me
sac
dn̄s
qm̄
intrauerunt aque: us
qꝫ ad animam meā.
Infixus sum in li
mo profundi: et non
est substancia Ueni
in altitudinem ma
ris: et tempestas dein
sit me. Laboraui cla
mans rauce facte sūt
sauces mee: defecerūt
oculi mei dum spero
in deum meum. Mul
tiplicati sunt super ca
pillos capitis mei: qui

Isaiah

10 PSALTERIUM GRAECE
MANUSCRIPT IN GREEK ON VELLUM /
BYZANTIUM, CA 1300

For unto us a child is born, unto us a son is given: and the government shall be upon his shoulder: and his name shall be called Wonderful, Counsellor, The mighty God, The everlasting Father, The Prince of Peace. — Isaiah 9:6

Isaiah ranks as the staunchest among the major prophets, and while no historical document of his life exists, he appears time and again in both Testaments, often in prophetic visions and exhortations of the coming of the messiah. In his counsel urging Judah to keep out of foreign alliances and trust in God alone, Isaiah went so far as to implore his people to remain quiet and treat futile attacks with contempt. This derived from his confidence in the inviolability of Jerusalem and the coming of the Lord. "Behold, a virgin shall conceive, and bear a son, and shall call his name Immanuel," a prophecy, according to the Latin fathers, of the Annunciation. Later medieval lore tells that Mary was reading that very Bible passage when the angel Gabriel announced the will of God.

Before Handel wrote *The Messiah* in 1741, he asked a London clergyman to draw on the Bible for the text. The basso air, "The people that walked in darkness have seen a great light," is answered by one of the most powerful and compelling of choruses: "For unto us a child is born," the words of Isaiah.

The manuscript psalter was written in a most elegant and fluent cursive Greek hand, reminiscent of the great scribes of the eleventh and twelfth centuries; but for stylistic reasons, mainly of the miniatures, the manuscript must be assigned to, approximately, the year 1300, with the assumption that it is a copy of one of the great earlier court manuscripts. In one of the many miniatures by an artist of the school of Constantinople, following the ikon-like tradition of the time, Isaiah is holding the small figure of Christ with hand raised in blessing. The venerable old man in the costume of a byzantine priest with white hair and beard and a halo for holiness is represented in the splendid pose or gesture of introducing, if not presenting, Christ as the messiah, to the readers of the psalm.

τοῦ μι[...]η σαμ... ἐπὶ τ͞ι͞ω

δ͞ι͞ι αὐτὸν· ω̅ ε̅

ἠσαΐου τὸν προφή(την)

κ͞ρ͞υ κτοσ ορθρίζει

τὸ τῶ αμ...ω...

σο ὁ θ̅σ̅· διότι φῶς

τὰ προστάγματα

σου ἐπὶ τῆσ γῆσ

Δικαιοσύνην μάθε-

τε οἱ ἐνοικοῦντ͞ε͞ς

ἐπὶ τῆσ γῆσ π͞ε

παύται γὰρ ὁ ἀ͞ω

ἡσ.ου μὴ μάθη δικαιο

σύνην· ἐπὶ τῆσ γῆσ ἀλή-

θ͞ι͞α͞ν ὁ μὴ ποιήσῃ·

Isaiah Sawn Asunder

11 SYNAXARION or LEGENDS OF THE SAINTS
COPTIC MANUSCRIPT IN ARABIC ON PAPER /
EGYPT, 17TH CENTURY

Of the increase of his government and peace there shall be no end, upon the throne of David, and upon his kingdom, to order it, and to establish it with judgment and with justice from henceforth even for ever. The zeal of the Lord of hosts will perform this. — Isaiah 9:7

As Isaiah continued to prophesy the continuity of the throne of David and thus the coming of the Christ, the almost violent anti-prophetic reaction of Manasseh, ancestral head of one of the tribes of Israel, increased. So foul were his deeds, as reported in the Bible, that he made his son "pass through the fire," introducing the cult of the Assyrian astral system; he used "enchantments and dealt with familiar spirits and wizards"; he persecuted the prophets in their righteousness; he even practiced human sacrifice. For his sins, Manasseh was taken prisoner by the king of Assyria, bound in fetters, and carried to Babylon.

The Bible does not tell us of an incident which has become a legend of Isaiah's, and is often depicted in later art. The legend, adding to the already lurid account of Manasseh's cruelties reported in the Book of Kings, is that Manasseh, when enraged by the prophet's insistence on his message, commanded Isaiah to be spread across the branches of a strong tree and sawn asunder.

In the illustration, Isaiah, saw in hand as a symbol of his martyrdom, stands upright, with hand on heart and a halo representing sainthood. His expressive and benign face radiates the goodness of his calling. The illustration is one of ninety-six colored drawings in a Coptic manuscript, written in Arabic during the seventeenth century, relating the stories of the saints, and drawn from the Coptic *Synaxarion* or Golden Legend. The scribe, Ghubriyal ibn Sulaiman, is named on one of the pages, but there is no indication of the name of the artist who drew the pictures, primitive yet story-telling and in each case identified in English by inscriptions supplied by a nineteenth-century owner.

فنشره بمنشار من حتت السنديان من راسه الى اسفل وتناءً
فوق السبعاس سنه وسبق ورّوده السيد المسيح بتسعمايه وثلاثه عشر سنه
صلواته تكون معنا امين صورة اشعيا النبي والمنشار الذي نشره به في يده

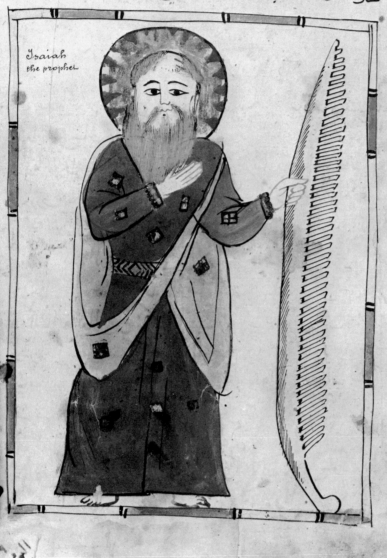

Isaiah the prophet

The Tree of Jesse

12 THE TICKHILL PSALTER

MANUSCRIPT IN LATIN ON VELLUM / ENGLAND,
PRIORY OF WORKSOP, CA 1310

And there shall come forth a rod out of the stem of Jesse, and a Branch shall grow out of his roots. — Isaiah 11:1

Here, again, is Isaiah prophesying the coming of the messiah! And from the rod of Jesse! Jesse, father of David the King, was a Judaean from Bethlehem, perhaps the headman of the village; Isaiah stresses the contrast between small beginnings and future glory for Jesse is always mentioned in connection with his illustrious son. Both names have come to symbolize the royal family and the messianic hope involved.

The full-page miniature of the Tree of Jesse from the Tickhill Psalter is a magnificent example of English Gothic art of the early fourteenth century, somewhat under the influence of French examples in the fashion of the time. The Tree is divided into panels: Jesse, in the center one, lies asleep. From his side spring forth branches enclosing David, playing the harp; the Virgin Mary with the Christ child; and Christ in Majesty, with orb and dove; and a representation of the Holy Ghost at the very top. On either side and within roundelled branches are ten patriarchs, while within niches of the outer panels stand, imposingly, six great prophets of the Old Testament. Below are two scenes from the life of David: keeping his father's sheep, and defending the ram from the attack of a lion — deeds symbolic of the Good Shepherd and of the Defender of the Faith.

The Tickhill Psalter, written and partly decorated by John Tickhill, the Augustinian prior of the monastery of Worksop in the Midlands is an unusual example of bookmaking of the English Middle Ages in which both scribe and gilder are named. Its text begins with a preface by Petrus Lombardus the learned twelfth-century theologian and archbishop of Paris; and the text is that of the Gallican Psalter in Saint Jerome's translation of the Septuagint, made in Bethlehem in 382. With its seven full-page miniatures of color and pure gold, and more than 466 smaller marginal scenes from the Old Testament, the psalter is an extraordinary ambassador of medieval England.

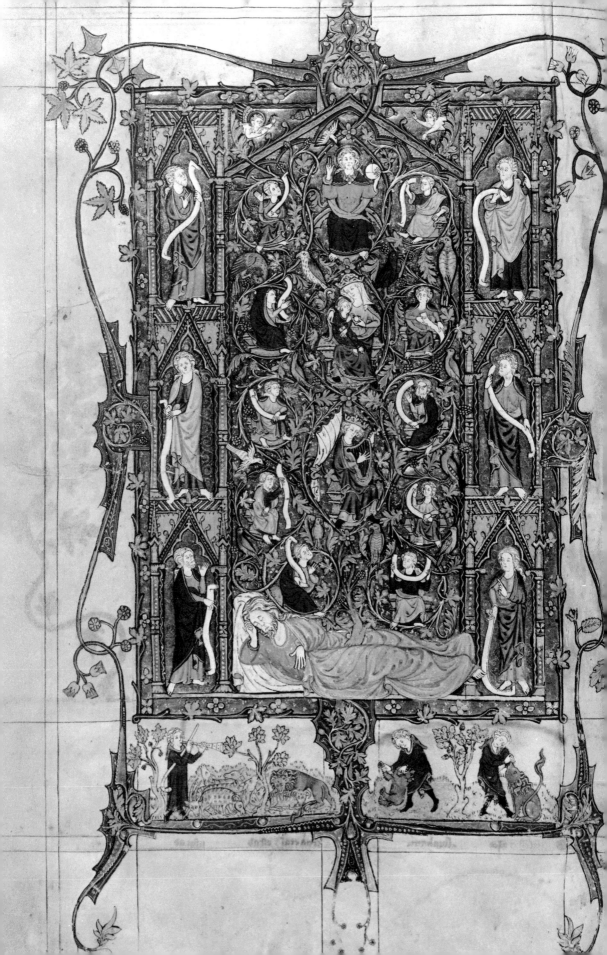

13 BIBLIA LATINA

MANUSCRIPT IN LATIN ON VELLUM /
ITALY, 13TH CENTURY

And in that day there shall be a root of Jesse, which shall stand for an ensign of the people; to it shall the Gentiles seek: and his rest shall be glorious. — Isaiah 11:10

Isaiah's prophecy implied in the root of Jesse is literally given at the beginning of Saint Matthew: *Liber generationis Jesu Christi, filii David, filii Abraham,* followed by the geneaological sequence of the generations of the ancestors of Christ.

The initial letter "L," which begins the Latin Gospel according to Saint Matthew, comes from a large and handsome Italian Bible manuscript written sometime during the latter part of the thirteenth century, possibly in Southern Italy. It is decorated with ninety-two story-telling initial letters almost byzantine in their stillness and simplicity. Again, we find Jesse asleep at the root of the tree, reclining rather than lying down; the root is shooting upwards, and within its entwining branches are the portrait busts of the immediate ancestors of Christ: the crowned David with his harp; Solomon holding a sceptre, symbol of royalty; the Virgin Mary with hands upheld in prayer and supplication; and a young and beardless Christ. Isaiah's prophecy here recalls to the reader the true "ensign of the people."

incipit plog ieronimi in mattheum euangelistam

Matteus ex iudea sicut in ordine primus ponitur: ita euangelium in iudea primus scripsit, cuius uocacio ad deum ex publicanis actibus fuit, duorum in generacione xpi principia presumens, uni9 per abraam: alteri9 per dauid ex electione sortiti sunt. ...

littere ex iudea sicut in ordine primus ponitur: ita euangeli-
um in iudea primus scripsit,
uocacio ad deum ex publicanis
actib9 fuit, duorum uesligia
ceus xpi principia psumens ue9 uni9 sceu9 p
ma acumine meanie alterius. uni9 fiii
per electionem fuit. Genus secundum
puru9 rex. Sicut reru dauid nascendo...
formem posito, peragum accede-
ret sue in electionis tempus poragens ...

Abraam genuit ysaac, ysaac autem genuit iacob. Ia-
cob autem genuit iudam & fratres eius. Iudas autem
genuit phares & zaram de thamar. phares
autem genuit esrom. Esrom autem genuit ara-
dram aram autem genuit aminadab. Aminadab
autem genuit naason. Naason autem genuit
salmon. Salmon autem genuit booz de raab.
Booz autem genuit obeth ex ruth. Obeth autem
genuit iesse. Iesse autem genuit dauid re-
gem. Dauid autem rex genuit salomonem ex
ea que fuit urie. Salomon autem genuit roboam...

Roboam autem genuit abiam. Abia autem
genuit asa. Asa autem genuit iosaphat. Io-
saphat autem genuit ioram. Ioras autem ge-
nuit oziam. Ozias autem genuit ioatham. Ioatham
autem genuit achaz. Achaz autem genuit eze-
chiam. Ezechias autem genuit manassen.
Manasses autem genuit amon. Amon autem
genuit iosiam. Iosias autem genuit iechoni-
am & fratres eius in transmigracione babilonis.
Et post transmigracionem babilonis. Ie-
chonias genuit salathiel. Salathiel autem ge-
nuit zorobabel. Zorobabel autem genuit abi-
ud. Abiud autem genuit eliachim. Eliachim
autem genuit azor. Azor autem genuit
sadoch. Sadoch autem genuit achim. A-
chim autem genuit eliud. Eliud autem genu-
it eleazar. Eleazar autem genuit mathan. Ma-
than autem genuit iacob. Iacob autem genu-
it ioseph uirum marie. de qua natus est ihesus
qui uocatur xpus. Omnes ergo generationes
ab abraam usque ad dauid, generationes
xiiii. Et a dauid usque ad transmigracionem
babilonis, generationes xiiii. Et a transmi-
gracione babilonis usque ad xpm generati-
ones xiiii. Xpi autem generatio sic erat. Cum
esset desponsata mater ihesu maria ioseph. an-
tequam conuenirent, inuenta est in utero ha-
bens de spiritu sancto. Ioseph autem uir eius cum esset iu-
stus, & nollet eam traducere, uoluit occulte
dimittere eam. hec autem eo cogitante, ecce
angelus domini in somnis apparuit ei dicens.
Ioseph fili dauid, noli timere accipere mari-
am coniugem tuam. Quod enim in ea na-
tum est, de spiritu sancto est. Pariet autem fili-
um, & uocabis nomen eius ihesum. Ipse enim sal-
uum faciet populum suum a peccatis eorum. Hoc
autem totum factum est, ut adimpleretur quod
dictum est a domino per prophetam dicentem. Ec-
ce uirgo in utero habebit, & pariet filium, & uo-
cabunt nomen eius emanuel. Quod est in-
terpretatum nobiscum deus. Exurgens autem
ioseph a sompno, fecit sicut precepit ei angelus domini.
Et accepit coniugem suam. Et non cognoscebat
eam donec peperit filium suum primo-
genitum. & uocauit nomen eius ihesum. Cum
ergo natus esset ihesus in bethleem iude, in die-
bus herodis regis, ecce magi ab oriente ue-
nerunt ierosolimam dicentes. Ubi est qui na-
tus est rex iudeorum? Uidimus enim stel-
lam eius in oriente, & uenimus adorare eum.
Audiens autem herodes rex turbatus est, & omnis
ierosolima cum illo. Et congregans omnes prin-
cipes sacerdotum, & scribas populi, sciscitaba-
tur ab eis ubi xpus nasceretur. At illi dixe-
runt ei, In bethleem iude. Sic enim scriptum est
per prophetam. Et tu bethleem terra iuda, neq-
uaquam minima es in principibus iuda. ex
te enim exiet dux, qui regat populum meum...

14

BIBLIA LATINA

MANUSCRIPT IN LATIN ON VELLUM /
FRANCE, CA 1250

Behold, the days come, saith the Lord, that I will raise unto David a righteous Branch, and a King shall reign and prosper, and shall execute judgment and justice in the earth. — Jeremiah 23:5

So persistent and beautifully phrased are the prophecies of a messianic nature in Jeremiah's outcries, teaching, and writing that he is called the poet of the heart, the golden tongue among prophets. His vision of God who made him the first to see the rod of the almond tree in bloom after its deep winter's sleep, assured Jeremiah that his vocation had divine guidance. "Almond tree" in Hebrew also means "to be aware, to watch," and this in medieval theology and typology made the flowering tree represent the Church. To the Christian Church Jeremiah also served as a prefiguration of Christ and of Christ's Passion, and he is often represented with a cross, sometimes also with a manticore, a legendary beast with threefold rows of teeth, a lion's body, and a tail like the stinging scorpion that lives below the earth — as had Jeremiah in his agony when he was cast into the dungeon, let down with cords, and sank into the mire! Jeremiah's charging the people with disobedience and his foreboding of disaster give us a rare opportunity to hear, incidentally, of the writing of books in biblical times. In the thirty-sixth chapter, the Lord tells him: "Take thee a roll of a book, and write therein all the words that I have spoken unto thee against Israel."

The small manuscript Bible, almost pocket size, is written in Latin upon 516 leaves of the finest and thinnest vellum, in a minute and much abbreviated hand. It is open to the beginning of the Book of the prophet Jeremiah: *Verba Jeremiae, filii Helciae, de sacerdotibus qui fuerunt in Anathoth, in terra Benjamin* — The words of Jeremiah the son of Hilkiah, of the priests that were in Anathoth, in the land of Benjamin. The manuscript was written in Northern France, possibly Paris, some time during the thirteenth century.

15

BIBLE HISTORIAUS OU HYSTOIRES ESCOLATRES

MANUSCRIPT IN FRENCH ON VELLUM / FRANCE, 15TH CENTURY

How doth the city sit solitary, that was full of people! how is she become as a widow! She that was great among the nations, and princess among the provinces, how is she become tributary! — Lamentations of Jeremiah 1:1

With Isaiah and Ezekiel, Jeremiah is one of the three great prophets, and his weeping and his lamentations over the doomed city of Jerusalem have traditionally been interpreted as symbols of the life of Christ. The most striking likeness is seen in Jeremiah's vision of a new covenant which God will make with his people and in which the Gentiles will participate under the rule of a messianic king of the seed of David. In Jewish worship, the Book of Lamentations was appointed to be read at the annual commemoration of the destruction of Jerusalem. Scholarship has not upheld the earlier belief that the lamentations were written by Jeremiah himself, and has placed this somewhat contrived, literary product, reminiscent of Hebrew burial chants and laments, at a somewhat later time. The verses bemoan the destruction of the temple; the horrors of the siege are brought out; finally, the poet himself speaks and recalls the love of God and Jerusalem's hope for the future. In all these, the Christian Church saw a symbolic parallel to the suffering of Christ and the hope for man.

The "Historiated Bible or Theological Stories," as the title of the manuscript can be read, is the work of a thirteenth-century Northern French scholar, Guiars des Moulins, Dean of Saint Pierre d'Aire, Pas de Calais. From the Vulgate he adapted the Bible stories freely. "Comment siet la cité qui estoit pleine de peuple. Et comment est feite veuve cele qui estoit dame des contrées" is a paraphrase of the official wording but permissible in a book which is to tell the "stories of the Bible." The manuscript consists of three giant volumes, in bold Gothic, written at the beginning of the fifteenth century. It contains 197 miniatures by various anonymous hands, and was possibly written to the order of Aymar de Poitiers, grandfather of Diane, whose coat of arms can be seen on some of the pages. Aymar's books became the property of Diane de Poitiers, bibliophile and collector, who housed them in her Chateau d'Anet. There they remained until 1724 when the library was dispersed.

Ci commence la lamentacion
Iheremie le prophete.

Cy commence la lamentacion
iheremie le prophete.

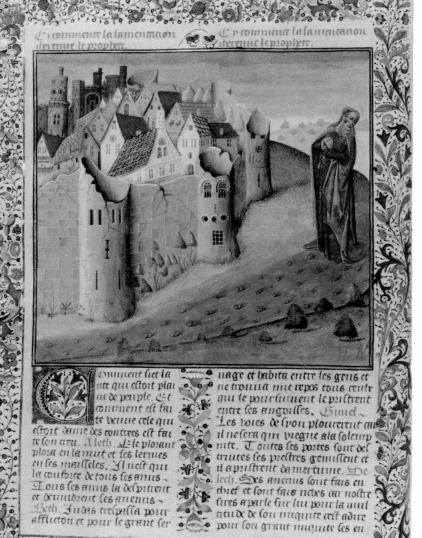

Omment siet la
cite qui estoit plai
ne de peuple. Et
comment est fai
te son ctu. Aleth. Ele plorant
plora en la nuit et ses lermes
en ses masseles. Il nest qui
la conforte de tous ses amis.
Tous ses amis la despurent
et deuindrent ses anemis.
Beth. Judas trespassa pour
afflicton et pour le grant ser

uage et habita entre les gens et
ne trouua mie repos tous ceulx
qui le poursiuuent le pristrent
entre ses angoilles. Gimel
Les voies de Syon plourerent car
il ne sera qui viegne ala solemp
nite. Toutes ses portes sont des
truites ses prestres gemissent et
il apristrent damertume. Deleth.
Ses anemis sont fais en
chief et sont fais riches car nostre
sires aparle sur lui pour la mul
atude de son iniquite cest adire
pour son grant iniquite ses en

Ezekiel

16 BIBLE HISTORIÉE ET VIES DES SAINTS

MANUSCRIPT IN LATIN AND FRENCH ON VELLUM /
FRANCE, CA 1300

*The heavens were opened, and I saw visions of God. . . . And I looked, and,
behold, a whirlwind came out of the north. . . . Also out of the midst thereof
came the likeness of four living creatures. . . . they four had the face of a
man, and the face of a lion, on the right side: and they four had the face
of an ox on the left side; they four also had the face of an eagle. — Ezekiel 1:1–10*

The vision of the Four Living Creatures assured Ezekiel that his ministry
was to have the approval and support of Jehovah. Following Isaiah and
Jeremiah, he was the third and last of the great prophets and the closest to
God. Does not Ezekiel in Hebrew mean "strengthened by God," and did
not his first vision give him the assurance that his ministry was blessed?
Later in life he became a stronghold for his people. Taken into captivity by
Nebuchadnezzar after the fall of Jerusalem, and living in a small colony of
exiles near Babylon, Ezekiel enjoyed a comparative measure of freedom.
So highly regarded was he by the Israelites that the elders of the community
visited him for consultation; he uttered prophetic discourses to large crowds;
he bolstered the morale of those in captivity, strengthening their hope in the
redemption and reconstruction of the nation. In one of his later visions, the
Lord spoke to him of the door of the tabernacle which was shut: "Then said
the Lord unto me; This gate shall be shut, it shall not be opened, and no
man shall enter in by it; because the Lord the God of Israel hath entered
in by it, therefore it shall be shut." In Christian interpretation this reference
to the closed door became both prophecy and prefiguration of the Immaculate
Conception, and in the later Middle Ages when the cult of Mary had blossomed
to unforeseen proportions, Ezekiel became one of the great who had foretold
the coming of the Christ.

The miniature shows the prophet deep in sleep, and in his dream or vision
seeing the Four Heavenly Creatures later symbolic of the Four Evangelists,
Matthew, Mark, Luke, and John. The power of the vision and the beauty
of the poetry inspired a Northern French artist to this iconographic rendering,
one of the many miniatures that make up this splendid picture Bible.

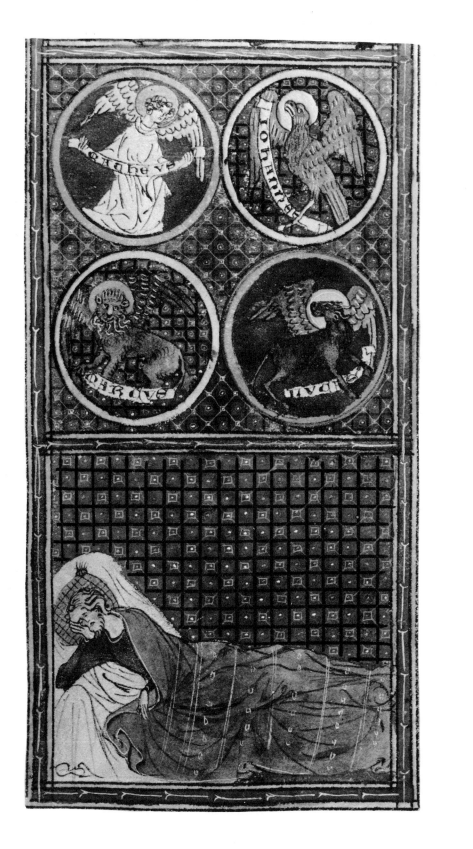

Daniel

OFFICIUM BEATAE MARIAE VIRGINIS

MANUSCRIPT IN LATIN ON VELLUM /
ITALY, FERRARA, CA1500

I saw in the night visions, and, behold, one like the Son of man came with the clouds of heaven, and came to the Ancient of days, and they brought him near before him. And there was given him dominion, and glory, and a kingdom, that all people, nations, and languages, should serve him: his dominion is an everlasting dominion, which shall not pass away, and his kingdom that which shall not be destroyed. — Daniel 7:13–14

In his vision of the Son of man, Daniel, a mythological figure for whom no historic evidence may be given and whom Saint Jerome calls a fable, is still considered one of the prophets who foretold the coming of Christ. Daniel's experiences during the Babylonian captivity make splendid reading and his many prophecies, his interpretation of Nebuchadnezzar's dreams, his opposition to empires, government, and oppression of the people, his miracle-like saving of the three Hebrews from the fiery furnace, as well as his own deliverance from the lions' den, establish him as a model of wisdom, patience, and justice. As Daniel was cast into the lions' den, and emerged miraculously unhurt, the Christian Church likened this event to that of Joseph's triumph in Egypt, and to the resurrection of Christ from the sepulchre. And when Daniel cries out: "And many of them that sleep in the dust of the earth shall awake, some to everlasting life, and some to shame and everlasting contempt," he evokes the inevitable struggle against the evil forces and the consequent testing of the faithful.

The thirteenth-century miracle play *Daniel*, performed in the churches of Beauvais and preserved in its contemporary manuscript form in the British Museum, is a deeply moving religious, and at times almost happy, popularization of a Bible lesson. It was recently revived in musical form and adapted into free verse by W. H. Auden: "So Daniel is down in the deep pit, Alone among the lions. But the Lord of Heaven Sends an angel with a sword to keep Those beasts at bay that they bite him not." The small portrait of Daniel, within an initial letter of the Ferrara prayer book, is unusual in that it shows the prophet bearded and of advanced age. The manuscript, a Book of Hours, contains a number of prophet portraits; it was written and illuminated towards the end of the fifteenth century.

recolimus patrocinia sentiamus; ↄ pa
cem tua nris concede temporibz; et
ab ecclia tua cuncti repelle nequitia;
iter; actus; et uolutates nras; ↄ om
nium famulorum tuorum i salutis
tue prosperitate dispone; benefacto
ribus nris sempiterna bona retbue.
et omnibz fidelibus defunctis requi
em eternam concede. p do. 7 ᵉ. ⁊.
Dne exaudi oionem meam. ℟ Et clamor me
us ad te ueniat ⁊ Benedicamus dno. ℟
Deo gras. ⁊ fidelium aie per misericordiam
dei requiescant in pace. ℟ Amen; Ad
complectorium ⁊
Onuerte nos deus
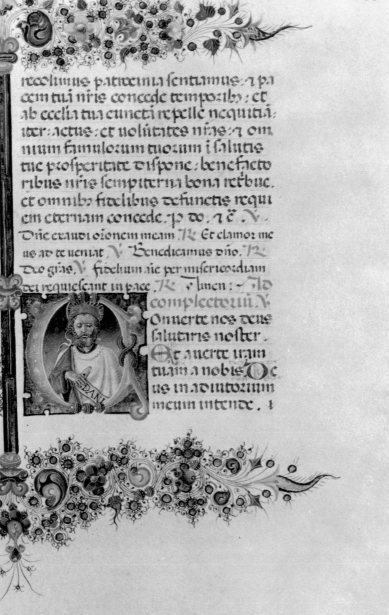
salutaris noster.
Et auerte iram
tuam a nobis Oc
us in adiutorium
meum intende. ⁊

18 THE BIBLE IN HEBREW

MANUSCRIPT IN HEBREW ON VELLUM /
GERMANY, XANTEN, 1294

*Now the Lord had prepared a great fish to swallow up Jonah. And Jonah was
in the belly of the fish three days and three nights. . . . And the Lord spake
unto the fish, and it vomited out Jonah upon the dry land.* — Jonah 1:17; 2:10

Jonah, the disobedient, the rebellious, the repentant, belongs to the group
of minor prophets; his book with its short four chapters reads like a tale
from the Thousand-and-One-Nights. Yet it contains a prophecy and a moral
lesson which have made the book and its hero beloved by story-tellers and
artists alike. Jonah's call to go to Niniveh and preach repentance; his
disobedience; his escape; his being cast into the sea in punishment; his
deliverance after three days and three nights within the belly of the whale —
all these are known as the "sign of Jonah," regarded in New Testament
times as a prophecy of the Resurrection. Christ speaks of Jonah in the
twelfth chapter of Matthew: "For as Jonah was three days and three nights
in the whale's belly; so shall the Son of man be three days and three nights
in the heart of the earth."

The illustrated page from the thirteenth-century Hebrew manuscript
showing Jonah vomited by the whale "upon dry land" and joyfully grasping
at leaves and plants, heads the beginning of the Book. Within the delicate
scroll work, there are other animals drawn by pen and ink and lightly
touched with color. It is unorthodox and unusual for a Hebrew Bible to
carry illustrations. Even in the tenth and eleventh centuries these manuscripts
usually contained traditional pattern design only. Yet, a little later in time,
restrictions loosened and drawings illustrative of the text did appear. The
manuscript in the Spencer Collection contains a most charming and touching
colophon: "I, Joseph of Xanten, son of Kalonymus from Neuss have written
and handed over these 24 books to my friend Moses, the 21st of the month
of Sivan, in the year 5054 [1294 AD] of the Creation of the World, and the
Creator may let him live to study these books until the end of the days.
Amen, Amen, Amen, Selah."

יַעֲשֶׂה לָךְ גְּמֻלְךָ יָשׁ

וּב בְּרֹאשֶׁךָ כִּי כַּאֲשֶׁר

שְׁתִיתֶם עַל הַר קָדְשִׁי

יִשְׁתּוּ כָל הַגּוֹיִם תָּמִיד

וְשָׁתוּ וְלָעוּ וְהָיוּ כְּלֹא

הָיוּ וּבְהַר צִיּוֹן תִּהְיֶה

פְלֵיטָה וְהָיָה קֹדֶשׁ וְיָר

שׁוּ בֵּית יַעֲקֹב אֵת

מוֹרָשֵׁיהֶם וְהָיָה בֵית

יַעֲקֹב אֵשׁ וּבֵית יוֹסֵף

לֶהָבָה וּבֵית עֵשָׂו לְקַשׁ

וְדָלְקוּ בָהֶם וַאֲכָלוּם וְלֹא

יִהְיֶה שָׂרִיד לְבֵית עֵשָׂו

כִּי יְהוָה דִּבֵּר וְיָרְשׁוּ ה

הַנֶּגֶב אֶת הַר עֵשָׂו וְת

וְהַשְּׁפֵלָה אֶת פְּלִשְׁתִּים

וְיָרְשׁוּ אֶת שְׂדֵה אֶפ

אֶפְרַיִם וְאֵת שְׂדֵה

שֹׁמְרוֹן וּבִנְיָמִן אֶת

הַגִּלְעָד וְגָלֻת הַחֵל

הַזֶּה לִבְנֵי יִשְׂרָאֵל אֲשֶׁר

כְּנַעֲנִים עַד צָרְפַת וְגָלֻת

יְרוּשָׁלַם אֲשֶׁר בִּסְפָרַד

יִרְשׁוּ אֵת עָרֵי הַנֶּגֶב

וְעָלוּ מוֹשִׁעִים בְּהַר

צִיּוֹן לִשְׁפֹּט אֶת הַר עֵשָׂו

וְהָיְתָה לַיהוָה הַמְּלוּכָה ‪:‬

חזק

והנבואה
זו יום
כפור

יונה

דְּבַר יְהוָה אֶל יוֹנָה בֶן

אֲמִתַּי לֵאמֹר ‪:‬ קוּם לֵךְ

אֶל נִינְוֵה הָעִיר הַגְּדוֹלָה

וּקְרָא עָלֶיהָ כִּי עָלְתָה

רָעָתָם לְפָנָי ‪:‬ וַיָּקָם יוֹנָה

לִבְרֹחַ תַּרְשִׁישָׁה מִלִּפְנֵי

יְהוָה וַיֵּרֶד יָפוֹ וַיִּמְצָא

אֳנִיָּה בָּאָה תַרְשִׁישׁ וַיִּתֵּן

שְׂכָרָהּ וַיֵּרֶד בָּהּ לָבוֹא

עִמָּהֶם תַּרְשִׁישָׁה מִלִּפְנֵי

יְהוָה ‪:‬ וַיהוָה הֵטִיל רוּחַ

גְּדוֹלָה אֶל הַיָּם וַיְהִי סַעַר

גָּדוֹל בַּיָּם וְהָאֳנִיָּה ח

חִשְּׁבָה לְהִשָּׁבֵר ‪:‬ וַיִּירְאוּ

הַמַּלָּחִים וַיִּזְעֲקוּ אִישׁ

אֶל אֱלֹהָיו וַיָּטִלוּ אֶת

הַכֵּלִים אֲשֶׁר בָּאֳנִיָּה אֶל

הַיָּם לְהָקֵל מֵעֲלֵיהֶם

וְיוֹנָה יָרַד אֶל יַרְכְּתֵי

הַסְּפִינָה וַיִּשְׁכַּב וַיֵּרָדַם

וַיִּקְרַב אֵלָיו רַב הַחֹבֵל

וַיֹּאמֶר לוֹ מַה לְּךָ נִרְדָּם

קוּם קְרָא אֶל אֱלֹהֶיךָ

אוּלַי יִתְעַשֵּׁת הָאֱלֹהִים ל

19 BIBLE HISTORIAUS OU HYSTOIRES ESCOLATRES

MANUSCRIPT IN FRENCH ON VELLUM /
FRANCE, 15TH CENTURY

Now there was in Jewry a prophet, called Habbacuc, who had made pottage, and had broken bread in a bowl, and was going into the field, for to bring it to the reapers. But the angel of the Lord said unto Habbacuc, Go, carry the dinner that thou hast into Babylon unto Daniel, who is in the lions' den. And Habbacuc said, Lord, I never saw Babylon; neither do I know where the den is. Then the angel of the Lord took him by the crown, and bare him by the hair of his head, and through the vehemency of his spirit set him in Babylon over the den. — Apocrypha: Bel and the Dragon: 33–36

This touching incident in the life of Habbacuc comes from the Apocrypha and, proving its popularity, has often appeared in painting and sculpture. To the Middle Ages the incident was taken typologically as a prefiguration of the Eucharist, and some said that the rolls which Habbacuc carried had the Cross of Saint Andrew upon them, anticipating the Last Supper. Habbacuc's vision and prophecy of the birth of Christ, the Nativity: "Between two Animals will you find Him," comes from Habbacuc's Canticle in the Septuagint, or Greek version of the text. Septuagint, so called, after the seventy-two scholarly translators of the third century before Christ who translated early Hebrew texts into Greek to the order of Ptolemaeus Philadelphus for his library in Alexandria.

The angel carrying Habbacuc by the tuft of his hair appears in a miniature within an early fifteenth-century French manuscript of Bible stories written and illuminated with more than 197 others by a group of fair artists from Northern France. It is a compelling little picture, with the prophet's eyes, hopeful but not convinced, turned to heaven, as he carries gifts of sustenance and salvation. It is not unamusing to remember that Mohammedans, to this day, shaving their heads leave a small tuft of hair in the back so that the angel may safely carry them to paradise.

diaon aprustraut la main
sur soy cat sur lui queult ta
malice ne trespalla nue tous
temps. Et sine nainn et com
mence abachut prophete

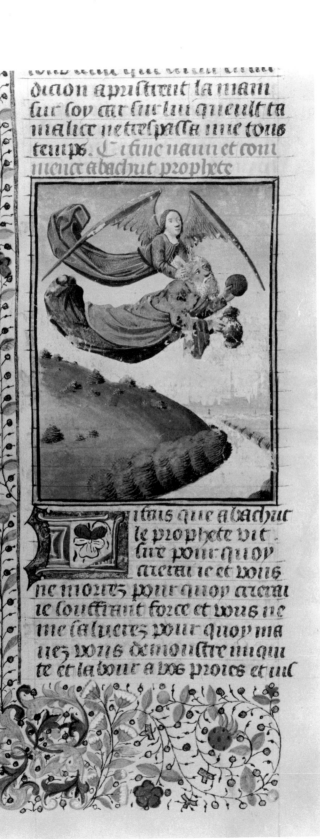

istns que abachut
le prophete vit.
sure pour quoy
airerai te et vous
ne mourez pour quoy airerai
te souffrant force et vous ne
me saluerez pour quoy ma
nez vous demoustre mqui
te et labour a bos proires et uil

Malachi

PROPHETAE MINORES ET ACTA SANCTORUM

MANUSCRIPT IN LATIN ON VELLUM / GERMANY,
MONASTERY OF WEINGARTEN, CA1225

Behold, I will send my messenger, and he shall prepare the way before me: and the Lord, whom ye seek, shall suddenly come to his temple. — Malachi 3:1

Malachi is the last of the twelve minor prophets in the books of the Bible, though not in date. Like so many of his forerunners, contemporaries, and successors he announces the coming of the messiah but also exhorts the nation to resist insincere worship and empty, corrupt, and unworthy priestcraft. But he promises that happiness and prosperity can and shall be restored by the regular payment of tithes and dues! In addition, the passage: "in every place incense shall be offered unto my name, and a pure offering," has often been quoted in Christian tradition from Saint Justin Martyr onwards as a prophecy of the Eucharist. It has also been said that Malachi's prophecies and poetry — he lived about 450 BC — were circulated in writing. A better explanation may be that the prophet's method of teaching became a favorite in the schools and synagogues of Judaism.

The miniature shows Malachi, seated within a large letter "O," the beginning of his book: *Onus verbi Domini ad Israel in manu Malachiae . . .* — The burden of the word of the Lord to Israel by Malachi. The miniature is part of an incomplete manuscript, of the minor prophets from Nahum to Malachi, and of the lives of the saints, including Saint Oswald of England, patron saint of Weingarten. The manuscript was written and illuminated in the monastery of Weingarten, near Lake Constance in Southern Germany, for its distinguished and scholarly Abbot, Berthold, who lived and worked in the early part of the thirteenth century. Its existence is duly recorded in the famous Berthold Missal of the Pierpont Morgan Library, written about the same time and also coming from the Weingarten scriptorium. And it is recorded there, and by title, that a number of manuscripts were written "de novo" for the scholarly and distinguished abbot-collector. The miniature and its thirty-four companions, painted in gouache, are unusual examples of the Weingarten school, severe in the draughtsmanship of the figures, stiff-necked and cramped in posture of wild intensity, and with deeply furrowed facial lines. There is such emphasis on the impact of the "message" that it is hard to reconcile the traditional, almost byzantine style of restraint and regality of the time with such avant-garde outbursts. Malachi's hands are tightly clasped, tension is in his shoulders, and his coat flies up high in a meaningful gust. He is intentionally most serious when he announces: "The Lord, whom ye seek, shall suddenly come to his temple."

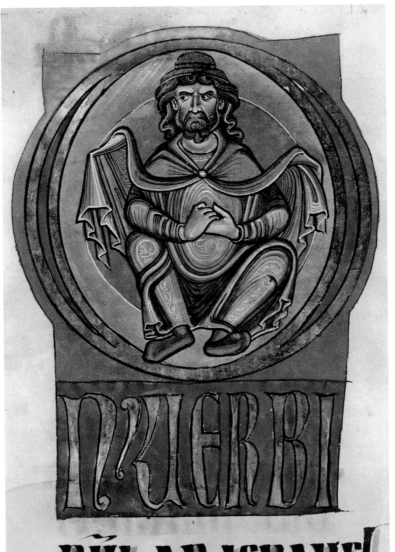

NUERBI

DÑI AD ISRAHEL
in manu Mala
chie ppheta. Di
lexi uos dicit do
minus. Et dixis

21 SPECULUM HUMANAE SALVATIONIS

MANUSCRIPT IN LATIN ON VELLUM / NORTHERN
GERMANY OR THE NETHERLANDS, CA1410

And he saw in heaven a virgin, passing fair, standing upon an altar, and holding a man-child, whereof he marvelled exceedingly; and he heard a voice from heaven saying: This is the Altar of the Son of God. — Mirabilia Romae

When the Roman Senators, overcome by the virtues of the Emperor Octavianus Augustus, desired to have him worshipped, he asked leave to consult the Tiburtine sibyl, prophetess from Tivoli, who told him: "From Heaven shall come the King evermore," pointing towards the apparition in the heavens. The *Mirabilia Romae*, a twelfth-century guide book of the marvels of Rome for the pilgrim, relates the legend and continues: "The Emperor straightway fell to the ground and worshipped the Christ that should come." An altar was erected to his order, on the very site of today's Santa Maria in Aracoeli on Rome's Capitoline Hill. The sibyls, connecting the Greek and Roman world with the Christian era, increased during the Middle Ages to the number of twelve to become the distaff side, typologically, of the twelve minor prophets. Like their ancestors, the Vestal Virgins, they were rewarded for their virginity, as Saint Jerome laconically discloses, by an ability to prophesy.

The miniature appears in the *Speculum Humanae Salvationis*, a harmony of Old and New Testament stories. It is a book for the unlearned, for those eager to learn, and for the teaching clergy; and it must have been most popular: more than two hundred manuscripts have come down to us. The miniature *Sibilla vidit virginem cum puero in cielo* is a simple, almost artless representation of the miraculous event. The Tiburtine sibyl with Octavianus Augustus next to her, points towards the Virgin and Child in the sky. A prophecy of the Nativity, indeed. It is one of 194 similar colored sketches in the manuscript, which according to an inscription once belonged to Joannis Wassenbergh *custodis montis sanctae odiliae*, Sankt Odilienberg in the Vosges mountains. The manuscript was written and illustrated in Northern Germany, possibly the Netherlands, at the beginning of the fifteenth century.

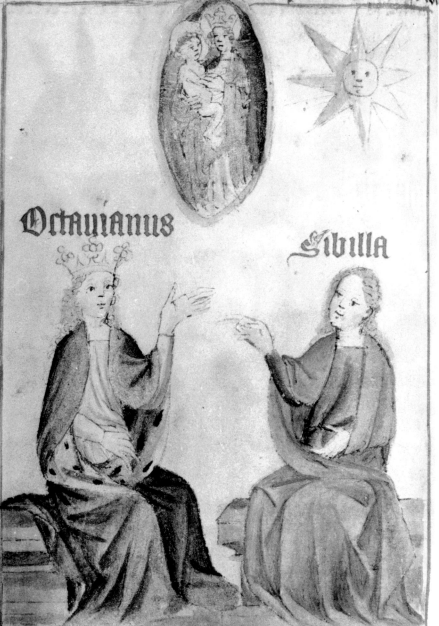

Part Two:

The Life of the Virgin

22 OFFICIUM BEATAE MARIAE VIRGINIS

MANUSCRIPT IN LATIN ON VELLUM /
ITALY, FERRARA, CA1500

*The rod of Jesse hath bloomed, a virgin hath brought forth God and man:
God hath restored peace, reconciling in himself the lowest with the highest.
Alleluia* — Responsory from the Mass of Our Lady: from the Purification
to Advent

The cult of Mary developed but slowly. Ignatius of Antioch of the first
century refers to Christ as "verily born of a virgin"; the Book of James or
Protoevangelium tells much of Mary's life but betrays lack of knowledge
of the Hebrew world and the Gospels; Ambrose of Milan in 350 called her
typus ecclesiae which became Saint Augustine's favorite connotation; the
council of Ephesus in 431 bestowed the title *theotokos* or *genetrix Dei*, the
Mother of God. Only later in the Middle Ages, Bernard de Clairvaux's *De
Laudibus Virginis Mariae* established the cult as we know it today. The
humanists moulded her into *notre dame* or *unsere liebe Frau*, and she has
remained as such in people's delight and devotion.

And so in art. If Mary and the Child look stern, uninviting, on the walls
of the Catacomb of Santa Priscilla in Rome, she appears in radiant byzantine
majesty in the mosaics of Santa Maria Maggiore a few hundred years later.
Soon her image emerges as the Virgin Enthroned, the Fair Lady of Chivalry,
the Beautiful Madonna, and finally, the familiar, comfortable and comforting
maiden of the people, the beloved Mother of God and the patron of the
afflicted and devout.

The miniature is the title page of an Italian Book of Hours or prayer book,
to be read at certain hours of the day by both clergy and any of the laity
who wish to partake. *Domine, labia mea aperies. Et os meum annuntiabat
laudem tuam* — You shall open my lips, O Lord. And my mouth shall declare
your praise. Mary, the Child in her arms, is the image of the *mater amabilis*.
Within the historiated and decorated border are four of Christ's ancestors: David
and Abraham, Moses and Aaron. God the Father, small and inconspicuous,
appears at the top directing Gabriel, Mary, and the Holy Spirit in the form
of a diminutive descending child, in the parts they are to play. To either side
of the border is the scene of the Annunciation: Gabriel, the messenger,
kneeling and giving the salutation: "Blessed art thou among women," holding
the lily, symbol of the Immaculate Conception — and to this day called
fleur de Marie by the French. Mary reading in her study — it has been said
that she was reading Isaiah's prophecy in Scripture, at that very moment —
turns her head sweetly and gracefully, acknowledging her calling.

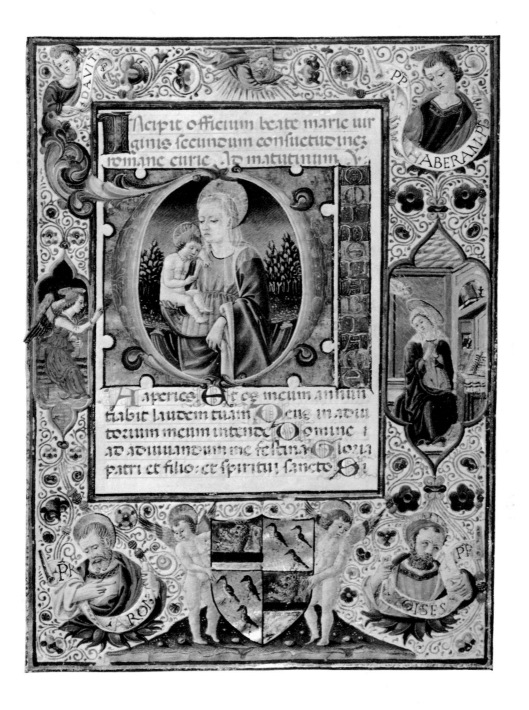

23 HORAE BEATAE MARIAE VIRGINIS

MANUSCRIPT IN LATIN ON VELLUM /
NETHERLANDS, 15TH CENTURY

Ad beatam virginem mariam: Obsecro te domina mea sancta maria mater dei pietate plenissima, summi regis filia mater glorissima mater orphanorum consolatio desolatorum. . . .

It is usually the Little Office of Our Lady, *officium parvum beatae mariae virginis,* representing a brief office in honor of Mary, modelled on the Divine Office, the obligatory prayer of the church, from which are read the seven "hours." It originated in the tenth century, being adopted by the Cistercians in the Monastery of Cîteaux where, later, Bernard de Clairvaux was to write his *De Laudibus Virginis Mariae* which produced a veritable outburst of the Marian cult.

The prayer of this manuscript page is not liturgical and seems to stem from Saint Bernard, perhaps Saint Bonaventura. Within the manuscript's many initial letters are some of the typological scenes from the Old Testament which were considered by exegetical theologians to be prophecies of the coming of the messiah. Scenes of the Immaculate Conception, the Annunciation, the Nativity, were likened to the Burning Bush, Aaron's Rod, the Closed Door of Ezekiel, Nebuchadnezzar's Dream, even Habbacuc's coming to the rescue of Daniel. But the more appealing part of the manuscript to the eye are the many delicious borders of insects and flowers, set upon a background of pure gold. The butterfly with its range of color and movement, symbolizes the resurrection of Christ, and in its cycle of caterpillar, chrysalis, and butterfly, the hope and resurrection of man. Since all flowers were dedicated to Mary, many are highly symbolic: the cyclamen with its red spot signifies the bleeding sorrow of Mary's heart; the violet is the symbol of humility: the columbine is the dove, meaning the Holy Ghost; the carnation symbolizes pure love — and to this day is worn by Flemish and Dutch bridal couples on their wedding day; the lily, the finest of them all, implies purity — it was later to become the emblem of royalty. There is a legend that a certain knight who could never remember more than the first two words of the *Ave Maria* had died, addressing to Mary his stumble of a prayer. The Virgin heard his plea, accepting his faulty memory, and a lily sprang from his grave, displaying on every blossom, and in golden letters, the words *Ave Maria.*

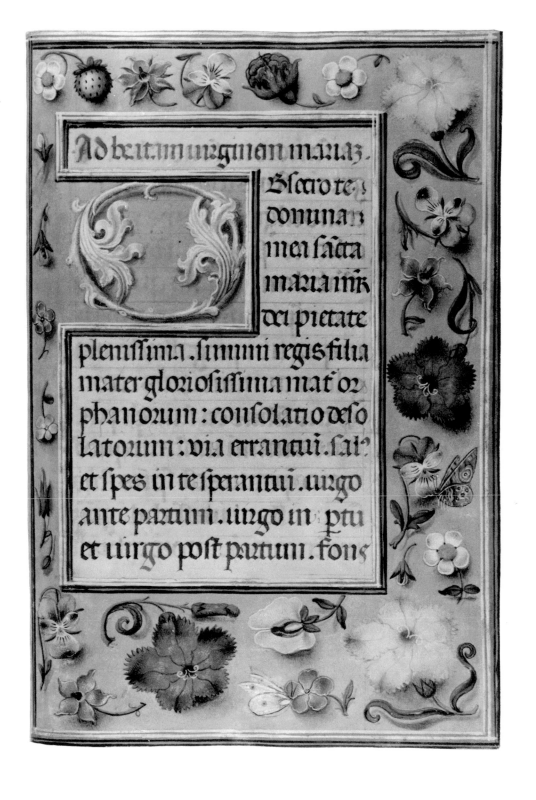

24 SERVICE BOOK OF THE ARMENIAN CHURCH

MANUSCRIPT IN ARMENIAN ON PAPER /
ARMENIA, 1489

And, behold, Ioacim came with the flocks, and Anna stood at the gate and saw Ioacim coming, and ran and hung upon his neck, saying: Now know I that the Lord God hath greatly blessed me: for behold the widow is no more a widow, and she that was childless shall conceive. — Book of James, or Protoevangelium IV:4

Both Anna and Joachim were of the house of David, coming from Nazareth and Bethlehem. In the story of Anna's barrenness and God's favor, they are the counterpart of the Old Testament motif of Abraham and Sarah, and they also prefigure the Immaculate Conception of the New Testament. Anna had mourned excessively, but on the advice of her maid, so the story goes, had adorned herself with her bridal dress. She had gone into the garden where a nest of sparrows sat within the laurel bush and it was there that the angel of the Lord appeared to her, announcing that she would be blessed with child. She rushed forth to meet Joachim who had been tending his flocks, and at the Golden Gate they embraced and vowed their child as an offering to God. When the child was born, they called her Mary.

Armenian manuscripts lack the splendor and the majesty of byzantine art. From it they derived great profit and stimulation, but there is a touch of provinciality in their compositions, an over-emphasis on movement in the illustrations, and a rather subdued use of color. The frontispiece to this Armenian Service Book of the fifteenth century — it is actually dated 1489 — represents the very scene of Joachim and Anna at the Golden Gate; even the nest of sparrows in Anna's garden had been taken there, with a domestic and symbolic touch of the mother bird feeding her young.

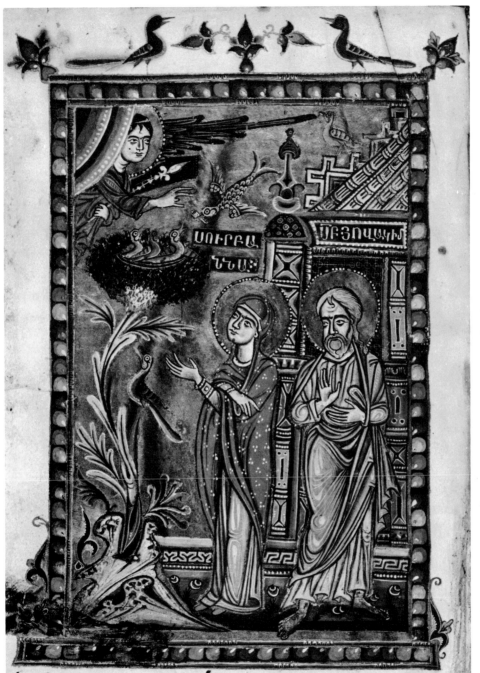

Ն հազար դէ կա։ Չ ի եւ ե ի Թ ա փ ա ռ ա կ ն ա ն
յ ա ւ տ ա պ ե ր կ ե ր վ ա ր ա ր ա կ ա ն ն ե ք վ ո ւ ա ր ձ ա ո տ ու ն
կ ն դ ր ու թ ե ն ։ ա ւ տ ա ր ա ց ա յ վ ա մ ա ր շ ա ո ւ ո ւ թ ե ն ։

The Birth of the Virgin Mary

25 MISSALE

MANUSCRIPT IN LATIN ON VELLUM /
GERMANY, BAVARIA, 15TH CENTURY

And her months were fulfilled, and in the ninth month Anna brought forth.
And she said unto the midwife: What have I brought forth? And she said: a
Female. And Anna said: my soul is magnified this day, and she laid herself
down. — Book of James, or Protoevangelium V:2

The Gospel of the birth of Mary, an apocryphal book, contains the narrative
of Mary's birth, her life in the temple, her betrothal to Joseph, her marriage,
the Annunciation, and the Virgin birth of Christ. It is a Latin work of the
Middle Ages which has at times erroneously been attributed to Saint Jerome
who, according to Jacobus de Voragine, had read of Mary's nativity "in a
certain little book." Voragine, the thirteenth-century archbishop of Genoa
and the compiler of the Golden Legend, himself relates unsubstantial detail
of blessed imagination in the life of the Virgin but reports the actual birth,
laconically, with a few words: "And Anna conceived and bore a child, and
called her name Mary." The fullest account of the actual birth, however, is
in the Book of James, or Protoevangelium, dating from the second century,
wrongly attributed to James the Apostle, probably compiled by a convert to
Christianity using the Gospels and several other sources, and to this day
surviving in a number of early Greek and Syriac manuscript versions.

The illustration of the birth of the Virgin Mary in medieval art is usually
an excuse for displaying a great deal of worldly and contemporary domestic
gear. Anna in bed, happy and reclining, is watching the babe laced in her
cradle, fast and enduring. Midwives fetch and carry. At times, the girl child
is being bathed and washed among a great many tubs, pitchers, and towels
and the swish of the midwives' skirts. It is an essentially cozy scene, one
of earthiness and promise, and close to the people.

This scene, within an initial letter of a Bavarian missal, once in the *conventus
ratisbonensis carmelitarum discalceatorum* — the Convent of the Barefoot
Carmelites of Regensburg — is a simplified, almost stylized rendering of the
hustle and bustle so often preferred. But its conventional background and
its sparcity of composition make mother and child stand out extremely well.
The initial "G" introduces the Mass of the Nativity of Our Lady: *Gaudeamus
omnes in Domino, diem festum celebrantes* . . . — Let us all rejoice in the
Lord, celebrating a festival day.

à ni sanctus ē in gla et phemiñ gaudio. vñ. DE
luccrnar. offic. PR. Osiuln dñe. Secret.
excensio quis dñe vñi Egidii Abbis nos
uera ura comendet; nos ne eius venia
de sancta. tue magestan reddat. accep
. Per. to. Magñ est gla. iplen. O ver
nr omps ds; ut qui celestia alimenta
rpim L. intercedente vñi Egidio Abbate
ura dia aduersa muniamur; et ad e
na gaudia consequieda. spes nobis.
perat et facultas. Per. Ju. Nacium
Beat. Marie virginis. Offinum.

NUDCAMUS

omes in dño diem festñi
celebrantes Ja honore
Marie virginis de auj
Nacuitate gaudet Au
gli et collaudat filiu di.
ps. Eructauit cor meu
verbū boñi dico ego o
pera mea regi. Orm.
Amilis nus
dñe quis celes
tis gracie munus
impertire; ut quibv vre virginis partus ex
ot salutis exordium. muitiuitatis eius
onta sollempnitas pacis tribuat incre
ientum. Pe. Sapiente.

26

OFFICIUM BEATAE MARIAE VIRGINIS

MANUSCRIPT IN LATIN ON VELLUM /
FRANCE, AVIGNON, CA1375

And Ioacim brought the child to the priests, and they blessed her, saying:
O God of our fathers, bless this child and give her a name renowned forever
among all generations. And all the people said: So be it, so be it. Amen.
— Book of James, or Protoevangelium VI:2

The Protoevangelium renders the fullest account of Mary's presentation and relates how "the priest received her and kissed her and blessed her" and how being placed upon the altar, she danced with her feet, so that all the house of Israel rejoiced with her, and loved her. And Mary was in the Temple of the Lord as a dove that is nurtured, and she received food from the hands of the angel. "And around the Temple there were fifteen steps," according to Jacobus de Voragine, "one for each of the fifteen gradual Psalms . . . and the Virgin placed upon the lowest of these steps, mounted all of them without the help of anyone." The *cantica graduum* or fifteen songs of degree of the Psalter connect Old and New Testament in imagery and verse: "I will lift up mine eyes onto the hills, from whence cometh my help," sings the Psalmist, and Mary demonstrates the faith in these words by ascending the steps unaided.

But it is perhaps best to look at the many representations in the arts, to recognize the impact this tale has had on man: Giotto's lofty mural in the Arena Chapel; the Limbourg Brothers' miniature in the Book of Hours of the Duc de Berry; Titian's breathtaking composition in Venice; and Dürer's cycle of woodcuts made as late as 1505, with the life of his own contemporary Nuremberg surrounding the scene. Mary, aloof, self-contained, dignified and incredibly lovable, ascends the steep steps in each instance: an unforgettable image.

The event within the initial letter "D" is reduced to the barest infinitesimal detail: the Temple, the steps, the priest. Mary ascending unaided except for the outstretched hands of her mother, behaving as any mother would instinctively do. The manuscript, pocket-size, compactly designed, is the work of Avignon, City of the Popes, who drew to it many Italian artists so that the town became a bastion of Italian artistic influence in France, stylistically and iconographically. The manuscript prayer book contains twelve calendar miniatures, nine full-page ones, and 128 historiated initial letters; each of its pages is surrounded by margins of delicate decorative foliage, often interspersed with drolleries drawn from secular and contemporary life. It was written probably about the year 1375.

27 LEBEN CHRISTI

MANUSCRIPT IN GERMAN ON PAPER /
GERMANY, 1440

*And when she was twelve years old, there was a council of the priests, saying:
Behold Mary is become twelve years old in the temple of the Lord. What
then shall we do with her? lest she pollute the sanctuary of the Lord.*
— Book of James, or Protoevangelium VIII:2

Hye kömen dye priester zü mariam vnd wolten ir einen man geben — Here,
the priests come to Mary and wish to give her a husband, reads the caption
above the illustration in the manuscript *Leben Christi.* According to the
Protoevangelium, Mary lived for years in the Temple where she received
instructions in Scripture. It was time, the priests or elders knew, to have her
married and taken from the sanctuary as was the Hebrew custom. Jacobus
de Voragine relates how "Mary had advanced in every virtue and was daily
visited by the angels." And in a letter, Jerome tells that the Blessed Virgin
had set herself a rule: from dawn to the third hour she devoted herself to
prayer, from the third to the ninth she worked at weaving, and from the
ninth hour she prayed until the angels appeared with food. Earlier, her mother,
so it is said, had taught her how to read, and while this fact is related neither
in the Bible nor the apocryphal books, it is much illustrated in the later
Middle Ages when the cult of Anna flourished. Now, that the priests had so
seriously spoken to her, Mary replied that she could not leave, nor be married.
Her parents had dedicated her to the Lord, and she herself had vowed her
virginity to God. Upon the High Priests' prayer for divine guidance, a voice
was heard "that all the marriageable men of the house of David who had
not yet taken a wife, each should bring a branch and lay it upon the
altar. . . ."

The popularly written and illustrated Life of Christ in this German
manuscript is a typical example of the form of book and the literature that
preceded the invention of printing. People were eager to read, and manuscripts
were copied one from the other: whole workshops working, the scribes
writing, untrained and often unoriginal illustrators copying a cycle of pictures
from earlier and similar manuscripts. Though the quality of calligraphy and
draughtsmanship is questionable, these manuscripts have character and a
style of their own. The manuscript of *Leben Christi* contains 256 pen and
ink drawings, many of them of most unusual iconography. It was made
in Southern Germany, possibly Swabia, and is dated 1440.

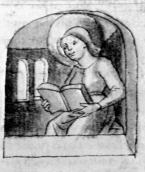

Do nu Maria in dem tempel was zu ir iar
alt warden Do sprachen die priester es wär
gots gepot die mayd die zu in rain wärn
komen dy soltn ehanschafft habe Also giengen sy zu ma-
ria vnd sprachen M Maria magst du pist erhöcht in
allen tugenten das dir yeder man hold ist Darumb pit-
ten wir dich das du deine vleis für dich nempst vnd
zu vnser ee schafft vnd nempst umb fraw eine man nach
gotes gepot vnd als es her dioyses gesetzt hat Das
von deine leib die welt gemert werd vnd da vo got
gelobt M Maria erschrack von dem wort vnd swaig
still vnd pat got taugentlichey das er sy weyst wie
sy anttwurt sult geben Das geschach also Sy sprach
sy wolt thains mannes weyb wardn Aba sy hiet in
eine man auserwelten in des selbigen heim lande wär
weder hunger noch durst noch thain lay vngemach

28 SYNAXARION OR LEGENDS OF THE SAINTS

COPTIC MANUSCRIPT IN ARABIC ON PAPER /
EGYPT, 17TH CENTURY

*Zacharias, Zacharias, go forth and assemble them that are widowers of the
people, and let them bring every man a rod, and to whomsoever the Lord shall
show a sign, his wife shall she be.* — Book of James, or Protoevangelium VIII:3

Joseph the carpenter threw down his working tools and took up his staff to go
before the priest with the rest of the widowers. And when he laid his staff
upon the altar, as had the others, the staff began to bud. One legend has
it that the others were so disappointed by this sign that they broke their
staffs; another version speaks of the dove that descended and settled upon
Joseph's staff and was unanimously accepted as coming from God. These
variations of the tale cannot be found in either Gospels or apocryphal
writings, but Joseph's staff might be typologically likened to Aaron's rod,
and the dove, bringing Noah and Moses to mind, might well represent both
purity and the God-sent Holy Spirit. Legendary sources for incidents in the
life of Joseph are sometimes dated as early as the fourth century, but it was
actually not until the fifteenth that his feast was given liturgical celebration.
About that time also, representations of the flowering staff appear, usually
a branch of the almond tree, sometimes with a dove on top.

This Coptic manuscript, written in Arabic, tells the tale, but its illustration
has an anachronistic touch. Joseph appears to be present at the presentation
of the very young child Mary with Joachim and Anna at her side, an event
some twelve years earlier than the miracle of the flowering staff. The Arabic
text itself is fairly close to the Book of James, or Protoevangelium: "Now
twelve God-fearing men from Judah gathered, took their staffs and went to
the temple. It was there that a dove flew down and rested on the staff of
Joseph, a sign of God that he was chosen as the just man; and he took Mary
to himself, and she stayed until the Angel Gabriel announced the birth of
the Saviour." This is from the third book of the *Kihak* of the Coptic *Synaxarion*,
written and illustrated with ninety-six colored drawings of the most primitive
rendering. It was written by Ghubryal ibn Sulaiman, the scribe whose name
is mentioned on folio 204, and was probably made in Coptic Egypt some
time during the seventeenth century. There is no name for the illustrator and
we must forgive him for Joseph's premature, anticipatory, but understandable
impatience!

Virgin Mary and Joseph the Carpenter.

29 LA VIE DE JESUS

MANUSCRIPT IN FRENCH ON VELLUM /
FRANCE OR FLANDERS, 15TH CENTURY

And the priest said unto Joseph: Unto thee hath it fallen to take the virgin of the Lord and keep her for thyself. — Book of James, or Protoevangelium IX:I

"And Joseph refused, saying: I have sons and I am an old man, but she is a girl: lest I become the laughing stock of the children of Israel." But the High Priest persuaded Joseph to take Mary and, to quote the Golden Legend, "when the espousals were completed, Joseph went back to his city of Bethlehem to make ready his house, and to dispose of all that was needful for the wedding." The Gospels tell us nothing of the actual marriage ceremony, nor do the apocryphal writings. One must turn to the legends. And there are reasons: to the ancient Hebrews marriage was a civil contract and not a religious rite; the ceremony as we know it was equally unknown to the early writers of Scripture. The East, with its emphasis on chastity and monasticism, brought marriage almost into disrepute; even the early Church fathers would have preferred denying marriage to Mary; yet Luke speaks of "a virgin espoused to a man whose name was Joseph, of the house of David," and so the Church yielded to this testimony as too direct to be set aside and allowed the recondite motives, and later, legends. The West was more chivalrous in its attitude. Bernard de Clairvaux, the Cistercian theologian of eleventh-century Burgundy, promises that the marriage of Mary would take whatever curse from every degree of womanhood, namely from virgin, wife, and widow — since, after all, Mary herself had been all of these.

The illustration of the manuscript *La Vie de Jesus* represents the marriage ceremony, simply and of its time, with the betrothed holding hands, *conjunctio manuum*, while the High Priest gives them his blessing. The scene has been moved into a small gothic chapel with slight anachronisms in costume: the bridal couple and their friends in clothes timeless yet medieval; the High Priest with mitre and cope. The simple composition in this simple manuscript is in contrast to the splendid and ecstatic late gothic and renaissance renderings which made a feast, a festival out of the ceremony. The manuscript was written and illustrated with thirty-seven similar pen and ink sketches in Northern France or Flanders in the fifteenth century.

Cy parle de la saincte natiuite de la glorieuse bier
ge marie · de sa conuersation · comment elle fut ma
riee a Joseph · puis parle du temps de lincarnation
de nre benoit sauueur ihus et des vtilitez de son
aduenement · Chappitre

Sainte Anne la mere de la bierge marie ot
vne soeur nommee hesmerie · Celle hesmerie
fut mere elizabeth · et dun filz qui ot nom
Eliud · Elizabeth fut mere de saint Jehan bap
tiste · Eliud entendra vnet enfant qui ot nom Emi
nen · Emmen entendra saint seruais qui puis fut
euesque de tongres · Quant sainte Anne ot porte la
bierge marie neuf mois en son ventre · elle sen deliura
et lui donna nom marie ainsi comme langele lui eut

The Annunciation

30

BIBLE HISTORIÉE ET VIES DES SAINTS

MANUSCRIPT IN LATIN AND FRENCH ON VELLUM / FRANCE, CA 1300

And in the sixth month the angel Gabriel was sent from God unto a city of Galilee, named Nazareth, To a virgin espoused to a man whose name was Joseph, of the house of David; and the virgin's name was Mary. — Luke 1:26–27

The Annunciation recalls many an Old Testament or other typological example or prototype. As the three angels of the Lord announced to Abraham the birth of Isaac, who was to become heir to the messianic message; as the angel of the Lord announced to Manoah's wife the birth of Samson, who was to deliver Israel from the Philistines; so did Gabriel, the messenger of God, announce to Mary the birth of the Saviour. And Mary herself recalls the Psalmist when he sings: "Hearken, O daughter, and consider, and incline thine ear."

Innumerable are the representations of the Annunciation: symbolic murals in catacombs, Santa Maria Maggiore's mosaics, the Rabula codex in Florence, Giotto in Padua, and untold miniatures in manuscripts from the sixth to the sixteenth century. Depending on date and country of origin, these representations range from humbleness, imperiousness, emotionalism, warmth and beauty, to comfortable domesticity. Throughout the centuries the scene has stood for faith and hope, and throughout the centuries artists, great and small, have given it their loving attention.

This miniature in the manuscript of the early fourteenth century is an example of the French Gothic par excellence. Against a background of stylized diaper pattern, Mary and Gabriel stand out like actors in a play and against a curtain; and well may a miracle play have been the source of inspiration to the artist, at a time when more realistic representation had not yet come. Gabriel, the guardian of the celestial treasure, the angel of Redemption, the messenger, whose name means "power of God," timeless and ageless, approaches Mary, raising his hand in blessing and salutation: *Ave Maria gratia plena!*

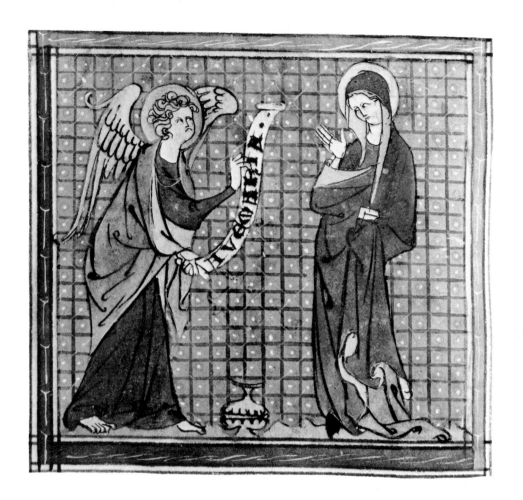

31 OFFICIUM BEATAE MARIAE VIRGINIS

MANUSCRIPT IN LATIN ON VELLUM /
FRANCE, AVIGNON, CA 1375

*And the angel came in unto her, and said, Hail, thou that art highly favoured,
the Lord is with thee: blessed art thou among women. — Luke 1:28*

The Little Office of Our Lady, *officium parvum,* is an essential liturgical text
for both clergy and laity. It is also a most personal book, the closest perhaps
in conversazione between the devout and his God. And so it became the
most frequently penned and illustrated of all the offices during the Middle
Ages; it invited patronage, personal possession, even vanity. But it also had
a decisive and lasting influence on the art of illustration and painting.

The unusual feature of this prayer book from Avignon in the Spencer
Collection is the number of full-page miniatures which seem to sum up or
introduce certain prayers, passages, or hours to be recited. Twelve calendar
leaves precede the actual text, exquisite genre scenes. For April a small
miniature shows two extremely fashionable ladies, Botticelli-like in their
litheness, posture, and dress, who entertain a handsome young knight offering
a wreath of flowers; May, now that spring has come, shows a proud falconer
prancing across the fields in pursuit of not very much; but November, in
preparation for the needs of winter, has peasants feed their bursting pigs
with more acorns. The full-page miniatures appear in pairs, with no text
on the reverse of their fine vellum leaves, as if they had been added later —
perhaps at the suggestion and pay of a donor or a patron?

Like a diptych, this Annunciation faces the graceful image of the Virgin
Enthroned — the one set against a stylized background often found in French
work of the time, the other against solid and blazing gold. Mary with the
Child in her arms, smiles at an adoring owner or patroness who kneels before
her, smaller in scale to prove her humility. Opposite is the illustration of our
interest: the Annunciation proper. Mary seated on a dais has outstretched
her hands in delighted acknowledgment of the message; Gabriel, breathlessly
"come in unto her" with wings almost in motion, holds a scroll: *Ave Maria
gratia plena; Dominus tecum; benedicta tu in mulieribus* — as reported by
Luke. God the Father, bearded and benevolent, is seen in the sky.

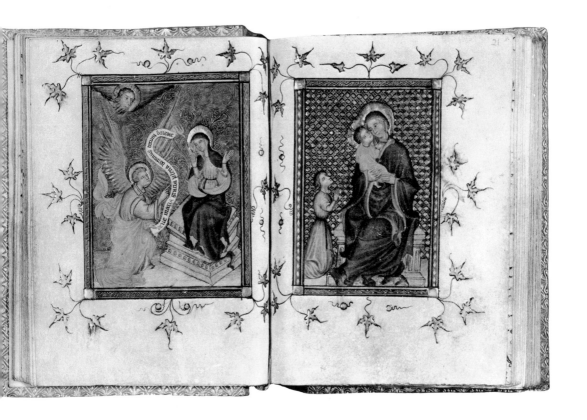

The Annunciation

32 ONS VROUWEN GETIJDE

MANUSCRIPT IN DUTCH ON VELLUM /
NETHERLANDS, UTRECHT, 1450

*And when she saw him, she was troubled at his saying, and cast in her mind
what manner of salutation this should be. And the angel said unto her, Fear
not, Mary: for thou hast found favour with God.* — Luke 1:29–30

Troubled by the impact and implication of the message, Mary somewhat
shrank back, girlishly, unprepared. "How shall this be, seeing I know not a
man?" But reassuringly "the angel answered and said unto her, the Holy
Ghost shall come upon thee, and the power of the Highest shall overshadow
thee: therefore also that holy thing which shall be born of thee shall be the
Son of God." Looking up from her book, comfortably seated in her bedroom
with its checkered tiles, a canopied bed, and curtains neatly folded, she appears
to have been more frightened than necessary by the light of the angel. His
kneeling, devoted, and sympathetic approach ought to have reassured her and
made her submit in humility. And does not Gabriel carry the sceptre, symbol of
authority, borne by princes on the earth and by the archangels in heaven?
Earlier, he had announced to Daniel the return of the Children of Israel
from captivity and to Zacharias Elisabeth's happiness and blessing. Now he
brings to Mary God's message, awkwardly abbreviated in our miniature to a
mere: *Ave gratia plena domin . . .* , as if the illustrating artist or scribe had
not been sufficiently dexterous in the use of space.

The simple, unpolished miniature, with its framework of latticed scrolls and
unrecognizable flowers, is also lacking in execution and finish. The calligraphy
on the opposite page, dominated by a handsome enough initial letter "H,"
with scroll work extending into the margins and with bold gothic lettering
that is firm and characteristic, is not too well aligned at the outer margin — as
if the scribe too lacked experience or patience. The words: *Here, du selte
opdoen mijn lippen — Domine, labia mea asperies* — You shall open my
lips, O Lord, from the Matins of the Little Office of the Blessed Virgin,
introduce the opening of *Ons Frouwen Getijde*, Our Lady's Hours, written
and illuminated in Utrecht. Provincial? Surely. Less refined, less finished than
the schools of neighboring Flanders so much closer to French influence. The
Dutch illuminator and scribe was ruder in speech, harsher with his brush.
Yet he did convey to his reader the impact of the Annunciation, even if set
into a burgher's house on the canals of fifteenth-century Utrecht.

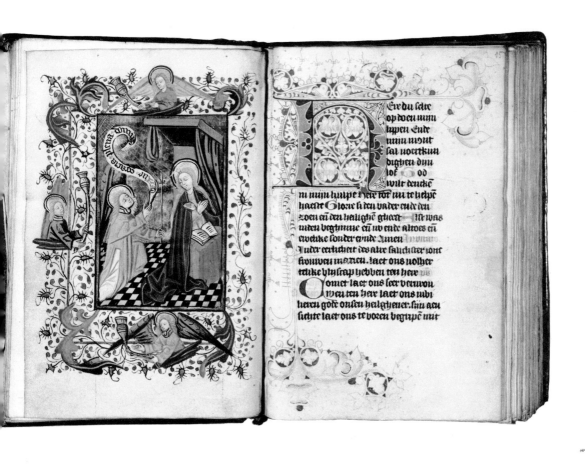

Cer du selte
op doen mün
lippen Ende
mün mont
sal voertbum
dighen dün
lof ꝺꝺ
wilt denckē
m mün hulpe Her vot mü te helpē
haeste Glorie si den vader ende den
zoen en den hellighē gheest Alsit was
inden beghinne en nv ende altoes en
ewelike sonder ende Amen
Inder eerlicheit des alre saluchster ion
frouwen marien. laet ons volher
telike blyscap hebben den here
Comet laet ons seer vervrou
wen ten here laet ons iubi
leren gode onsen heilghener. sün an
sichte laet ons te voren begripē mit

The Annunciation

33 HORAE BEATAE MARIAE VIRGINIS

MANUSCRIPT IN FRENCH ON VELLUM /
FRANCE, 15TH CENTURY

And, behold, thou shalt conceive in thy womb, and bring forth a son, and shalt call his name Jesus. — Luke 1:31

Paris, as the center for manuscripts being written and illuminated for royal and aristocratic patrons of the court and from neighboring centers, Burgundy, Bourges, Dijon, attracted not only patrons with an interest in works of art but also artists come from Flanders and the Netherlands to vie with the native Parisians. With all her hold on culture and patronage Paris might have brought about a deadening uniformity, but she accepted from the competing newcomers new styles and ideas and standards of performance which only enhanced the lustre of her fame.

The representation of the Annunciation in this fifteenth-century Book of Hours in the Spencer Collection bears proof of this development, if not miracle. The continual wars might have torn the capital apart and strangled the coffers of the patron if not the state. But the art of Paris continued to flower and even to influence that of the neighboring lands to an almost stifling degree. This double-spread miniature, assigned to the school of Northern France, is a telling combination of French *mise en scène* in architecture, and of Flemish realism in the rendering of nature, of "the world around us," as the artist might have said. Mary in great style, sophisticated, almost assured yet politely reserved as befitted a lady of chivalrous times, is here approached by a less breathless and more controlled Gabriel who merely raises his hand to make her understand, as one does in speaking, that the message is of the greatest import. Touched with gold, the scene is laid within the portals of a cathedral. Is it possible to assume that the columnar bas-reliefs represent prophets: Elijah, Isaiah, Jeremiah? In the background, the silvery light of Paris upon it, stands a proud castle such as one finds in the miniatures of the Limbourg Brothers, the Boucicaut Master, the school of Jean Fouquet. But the over-decorated and surrounding frame of the miniature seems un-Parisian and of Northern origin. Was the manuscript illuminated by one of the newcomers from Flanders?

"And he shall be great, and shall be called the Son of the Highest: and the Lord God shall give unto him the throne of his father David." Mary accepts, is deeply grateful.

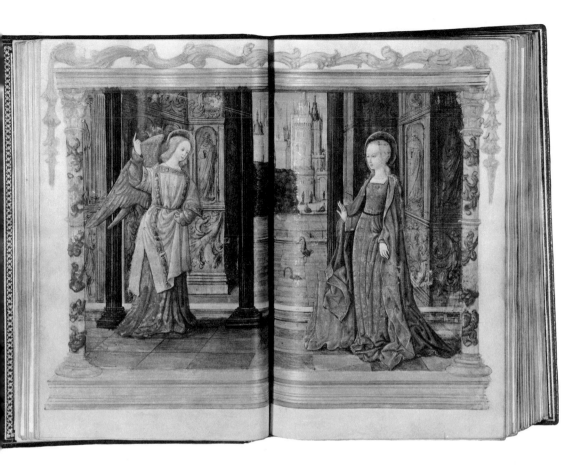

34 WINGFIELD HORAE ET PSALTERIUM

MANUSCRIPT IN LATIN ON VELLUM /
ENGLAND, CA1450

*And Mary arose in those days, and went into the hill country with haste, into
a city of Judah; And entered into the house of Zacharias, and saluted Elisabeth.
And it came to pass, that, when Elisabeth heard the salutation of Mary, the
babe leaped in her womb; and Elisabeth was filled with the Holy Ghost.*
— Luke 1:39–41

Bonaventura of Bagnoreggio near Viterbo, that saintly Franciscan theologian
of the thirteenth century, lovingly called *doctor seraphicus*, instituted the feast
of the Visitation, accepted by the Church one hundred years later. Its day
is the second of July, and the lily its symbol, a symbol also of Elisabeth and
Mary in their purity and blessedness, in their "salutation" and their "blessed
encounter" prefiguring the coming of Christ. Mary, shortly after her marriage,
hearing Elisabeth to be with child, went into the hill country to the dwelling
of Zacharias, where she was welcomed with humility and righteousness:
"Whence is this to me, that the mother of my Lord should come to me?"
This is considered the first recognition of the character of the messiah. Since
she had spoken through the influence of the Holy Spirit, and not through
knowledge, Elisabeth is considered a prophetess.

The Protoevangelium recalls that Mary forgot the "mysteries which Gabriel,
the archangel had told her," exclaiming: "Who am I, Lord, that all the
generations of the earth do bless me?" And she lived for three months with
Elisabeth and it was she who presented the babe John to his father Zacharias
before she left. And "day by day her womb grew, and she was afraid and
went home and hid herself from the Children of Israel."

Elisabeth is usually depicted as an older woman, "well-stricken in years";
the medieval caul for married women, if not the face, proves the artist of
our miniature to have understood the story. As often, the scene is laid within
the garden of Zacharias, highly regarded in Eastern tradition; Mary touching
simple flowers, so a legend tells, gave them heavenly scent. The miniature
is one of twenty-eight others that illustrate the Prayers and Psalter once in
the possession of Humphrey, Earl of Stafford. From him the manuscript
passed into the Wingfield family after whom it is named. *Deus in adiutorum
meum intende* — O God, come to my aid, the second versicle of Matins of
the Little Office, accompanies the extraordinary scene with its diminutive
house or castle, its stylized ikon-like landscape, its shadowless trees — all
proof of the English miniaturist's imagination and style: primitive, truthful,
full of character and of haunting beauty.

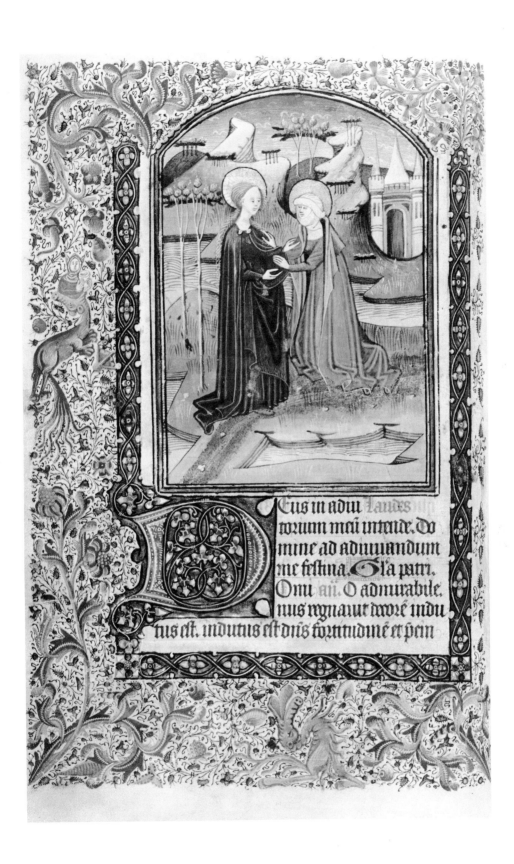

Eus in adiu laudes
torium meus intende. Do
mine ad adiuuandum
me festina. Gla patri.
Omu an. O admirabile.
nuis regnauit decore indu
tus est. indutus est dns fortitudine et præin

35 BIBLE HISTORIÉE ET VIES DES SAINTS

MANUSCRIPT IN LATIN AND FRENCH ON VELLUM / FRANCE, CA 1300

But while he thought on these things, behold, the angel of the Lord appeared unto him in a dream, saying, Joseph, thou Son of David, fear not to take unto thee Mary thy wife: for that which is conceived in her is of the Holy Ghost.
— Matthew 1:20

A satisfying and splendid manuscript in the Spencer Collection is this early fourteenth-century picture Bible, or *Bible Historiée*, with concisely abridged stories from Scripture, the text accompanied by an illustrative running cycle of 846 miniatures of high quality. Here the Bible and its pictures could be read without the help of a commentary; not by theologians versed in the *Bible Moralisée* with its endless typological and exegetical disputations and juxtapositions of Old and New Testament, but by laymen, even by those who were unlettered. Copied, that is, adapted, by a French scribe and illuminator, in both text and illustrations, from a Bible prepared to the order of the king of Navarre in the twelfth century, in Pamplona, and to this day kept in the library at Amiens, the Spencer Collection manuscript represents one of the fullest illustrated picture Bibles of the Middle Ages.

The manuscript page shown contains text and illustration of three successive events in the New Testament: the Visitation, Joseph's dream, and the journey of Joseph and Mary to Bethlehem to obey the Emperor Augustus's decree that one be taxed in one's home town. And while the miniature at the bottom of the page represents a most unusual and rarely seen iconographical presentation of the Journey — with Mary on foot, though immediately before the birth of her son, rather than seated on the ass led by Joseph — we are here mostly concerned with Joseph's dream, the central illustration. When Mary had returned from the visit to her kinswoman Elisabeth, Joseph found her great with child; "he smote his face and cast himself to the ground on sackcloth and wept." Later, and in his sleep, the angel of the Lord appeared to Joseph explaining the divine message, foretold by Isaiah, and allaying his doubts upon waking. In the miniature, Joseph is seated, asleep, restless, disturbed. The angel in contrast is sympathetic, consoling, reassuring, convincing. Matthew, unsmiling, reports: "Now all this done, that it might be fulfilled which was spoken of the Lord by his prophet," while the apocryphal books and the legends have indulged more than perhaps necessary. How refreshing then the simple French version: "Ioseph le mari de notre dame quant il aprit q'elle estoit plene et grosse se douta . . . mais il ne la vouloit pas accuser"!

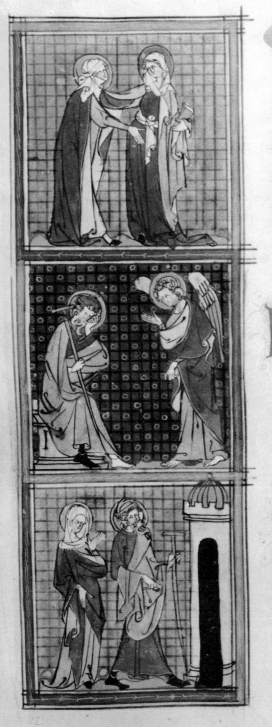

Et surgens maria abiit in mõ
tana &c. Apres ce sen ala nře
dame es montaignes ou demouroit
elyzabeth sa couzine la feme zaca
rie la qle estoit grosse de s. iehan son
fil & quãt elle lot saluee lenfant se
moust en son uentre & fust remplie encontre
la uenue nře & lors elizabeth rem
plie du s. esprit dist a nře dame. tu es
benoite sus toutes femmes & benoit est
le fruit de toi. Et comment il ore q̃ tu
q̃ es mere de nře seignes uiegnes a moi uray
ement iapesu bien des ta uenue quil
estoit ainsi car mõ enfant se esioi & remua
en mõ uentre. Beneure es qui as creu
aus parolles de lange car nře psera en
toi ce q̃ il ta dit nře dame. lame de moi
loe & mercie nře & mõ esprit sesiouit
en dieu mon sauueur &c.

Hec eo cogitante ecce angls dni
apruit ioseph dices &c. Ioseph
le mari nře dame qnt il apceut quelle
estoit plene & grosse se douta. & come il
fust preudõ & iuste il ne la uouloit pas
acuser ne manifest. mais pensa quil
sen iroit repostement & la laroit & en
ce penser langre nře li apput. naies
paour de merie ta feme. car ce quelle
a u uentre est du s. esprit & elle enfance
i. fil q̃ sera appele ihu q̃ sauuera son pue
ple & deliura de leurs pechies. &c.

Ascendit aut & ioseph a galylea
de ciuitate nazareth i iudea in
ciuitate dauid q̃ uocat bethleem &c.
Apres ce print ioseph nře dame tou
te grosse & lemena auec soi & se prtrét
de nazareth une cite de galylee & sen
aleret en iudee en la cite dauid quon
appeloit bethleem pce quil estoit du
lignage & de la mesme dauid. car il a
uoit este crie & comande de p lempereur
celar q̃ chscun se retraist en la cite dõt
il estoit nes. pour faire sauoir la descrip
tion & le nombre de tout le pueple.

36 THE ARCHANGELS GABRIEL AND RAPHAEL

MANUSCRIPT IN GE'EZ ON VELLUM /
ETHIOPIA, 18TH CENTURY

And Joseph was sore afraid and ceased from speaking unto her and pondered what he should do with her. And Joseph said: If I hide her sin, I shall be found fighting against the law of the Lord. — Book of James, or Protoevangelium XIX:1

A most unusual scene which, in a way, does belong to the Christmas story, is shown in an eighteenth-century Ethiopic manuscript of the legends and miracles of the archangels Gabriel and Raphael, as "told by Bishop Archelaus." Interspersed within the text is a small, column-wide, miniature or gouache painting of two scenes drawn within one composition. At the foot of the miniature, Joseph lies asleep while in a dream an angel, possibly Gabriel or Raphael, reveals to him not only the divine mission that, through Mary, has been cast upon his house, but also her purity and innocence. Mary, haloed, is draped in the native *shamma*, favored in Ethiopia and worn to this day by the country people; she raises her hand toward a smaller Joseph at her side, forgiving him for anger, unbelief, and doubt, while her lips were sealed.

Ethiopic manuscripts startle by their composition and color: the calligraphy of the literary and ecclesiastical language, called Ge'ez, is powerful and puzzling to the eye; it is derived from South Semitic script, and some believe that it was the creation of one man! The strong, stained-glass-window-like drawings, their range of color with red and yellow predominating, make us realize that Ethiopia is Africa, that her expression is individualistic and undaunted. Never under a conqueror for long, always autonomous, her arts have been flowering within conditioned limits for centuries. Few painters, muralists, or book illustrators, however, have dared to stray from accepted and established iconography, and in visiting the existing rock churches of an earlier epoch one is struck by the repetition of cycles, scenes, characters, with only occasional variation in composition. In this miniature of the Mentuab school, named after the Emperor of that name, near Gondar on Lake Tana of the middle of the eighteenth century, North African Christianity has given us a delightful, light-hearted introduction to the actual Christmas story.

ለወልድኪ፡እስመ፡ነገሬኒ
መልአክ፡ወእስብኪ፡በእንተ
አ ሁበቅድመ፡ቶሉ፡ወ
ህነተ፡ዘናፈቁ፡ዓጻጡ፡ናሁ
አእምኒ፡በቱሉ፡መዋዕሱሕ
ደወትየ፡እስመ፡መስሰኒ
እምዝመ፡ቱ፡ወ እቱ፡ወይ
እዚሰ፡አእመርኩ፡ከመ፡አ
መንፈቁ፡ቀዱስ፡ወእት፡ገ
ዊ፡እምይእዚሰ፡ወ ኩነ፡እግ
ዝእተ፡ለቤትየ፡ወእቱ፡ተነይ
ለኪ፡በፍሥሐ፡ወበገጹሕ
እስመ፡አነጸሕኩ፡ሐሊናየ
እምእኩይ፡ወአግብኡ፡ው
ስተ፡ቤቱ፡ወነበረት፡እንዝ
ያከብራ፡ወ ይትፈሣሕ
በቱ፡ወ ያዓብይ፡ወ ይትእ
ወይፈርኅ፡በልቡ፡ወ ያነ
ሁ፡ሥግሁ፡በጽሩይ፡ልቡ፡ወ
ሐሊና፡ወ እኑ፡ከመ፡መልእ

ክ፡ለፈጣራ፡ዓለም፡ወለእ
ዓዚ፡እ፡እየሱስ፡ክርስቶስ፡
ስብሐት፡ወ ክብር፡ ይኩዚ፡
ወዘልፈ፡ወ ለዓለመ፡ዓለ
ም፡እሜ፡ን

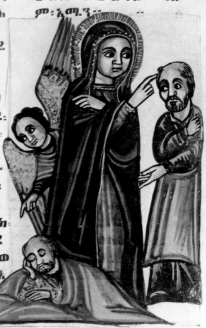

Part Three:

The Nativity

37 THE FOUR GOSPELS

MANUSCRIPT IN CHURCH SLAVONIC / RUSSIA, 15TH CENTURY

The book of the generations of Jesus Christ, the son of David, the son of Abraham. — Matthew 1:1

The evangelists or proclaimers of 'glad tidings' were travelling missionaries who fulfilled Christ's conception of ministry as recorded in the Epistle of Paul the Apostle to the Ephesians: "And he gave some, apostles; and some, prophets; and some, evangelists; and some, pastors and teachers." Traditionally believed to have been a tax gatherer for the Roman oppressors in Capernaum, Matthew of Galilee went to Ethiopia at the time of the dispersion of the apostles. There he taught, worked, and overthrew the powerful influence of the magicians. On visiting Egypt he brought back to life the son of the Pharaoh. Judaea, Macedonia, Spain, Persia, and India have been claimed as possible fields of activity. Yet he is supposed to have died in Ethiopia in the year 90 AD. His relics were said to have been taken by Robert Guiscard, dashing Norman adventurer and brother of the King of Sicily, first to Bretagne, then to Salerno. There the Cattedrale di San Matteo not only prides itself on a magnificent mosaic portrait of the evangelist made in Norman times over its portal, but in its over-decorated crypt, the remains of Matthew "brought from the East in 932 AD," so legend adds.

The Gospel according to Saint Matthew, in common with others, speaks but briefly of the Nativity. Within two chapters and twenty-two verses the cycle from conception to Epiphany is covered; his book is the book of the generations and is concerned with recording the words and works of Christ, the redemption of man. Behind the written narrative stands oral tradition, more or less fragmentary, and since Scripture fails to name any one author, it is rather from critical study of the text that authorship may be claimed.

From the earliest centuries of the making of liturgical books, the Four Gospels rated high and were produced by the most exalted and inspired scribes and illuminators, binders, gilders, and goldsmiths. The Gospel stood for the Word. As such it was of utmost significance and impact, even in physical appearance. To Matthew, Mark, Luke, and John were added the symbols: angel, lion, ox, and eagle. Soon, the author "portrait" developed: seated in majesty at first; the scholar's study thereafter. The author at work with desk, book, nib, inkwell, and the stillness of the retreat! Ikon-like is the rendering of Matthew in this manuscript; with that of the other Evangelists, it is part of a devout Russian monk's work some time during the fifteenth century.

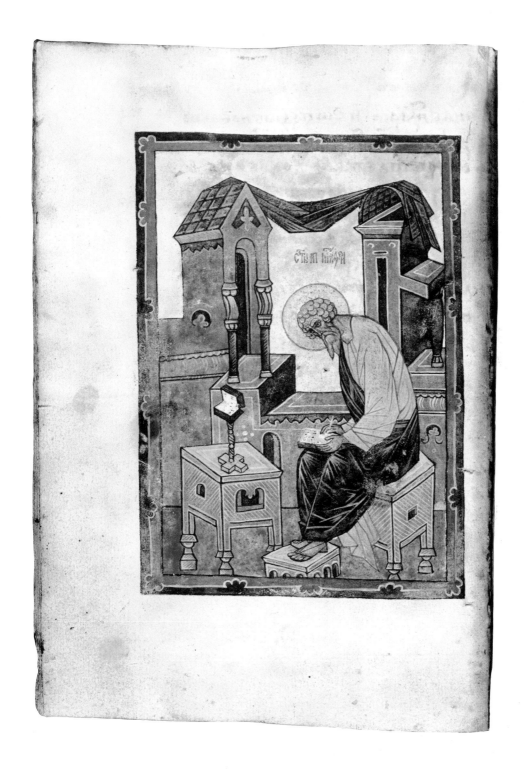

Saint Luke

LECTIONARIUM EVANGELIORUM

MANUSCRIPT IN LATIN ON VELLUM / ITALY, POSSIBLY LOMBARDY, 15TH CENTURY

It seemed good to me also, having had perfect understanding of all things from the very first, to write unto thee . . . , most excellent Theophilus.
— Luke 1:3

"Most excellent Theophilus," the recipient of the third Gospel, is said to have been an educated Gentile converted to Christianity. But Theophilus, "friend of God," and in need of further instruction and conviction, seems rather to represent the people to whom Luke the Evangelist wished to write. The facts about Luke himself are surrounded by fiction. Born in Antioch and converted after the Resurrection, he became Paul's favorite disciple, travelled with Paul to Greece and Italy, was shipwrecked with him on Malta, and was present at Paul's beheading in Rome. Egypt and Greece were visited, and in Patras he probably wrote most of his books. Buried near Patras, his remains were supposedly brought to Constantinople, to be kept in Justinian's magnificent byzantine Church of the Holy Apostles, burial place also of the byzantine emperors until the twelfth century.

The Christmas story is best known through Luke. It is known to Christians in unforgettable language, imagery, and moving detail; and to their children, impatient at the thought of the most wonderful gifts to come. "And it came to pass in those days, that there went out a decree. . . ."

Physician, Evangelist and painter! Luke took the fancy of legend and folk lore. Patron of painters, gilders, illuminators, he is closely connected with the arts. It has been said that a Madonna, carried by Gregory the Great through the streets of Rome against the great plague of 590 AD and now on the wall of the Borghese Chapel in Santa Maria Maggiore, is supposed to be from Luke's brush and easel. On the other hand Monsignor Joseph Wilpert, the byzantine scholar, attributes it to the thirteenth century!

In illo tempore: dixit Jesus discipulis suis . . . is the opening of the Mass for the First Sunday of Advent. The elongated initial letter "I" contains a contracted miniature of the scholarly Evangelist at a gothic desk with book, pen, and pen knife — an adoring ox, his symbol, tenderly looking towards its master. The *Lectionarium Evangeliorum* was written and illuminated in Italy, possibly Lombardy, in the fifteenth century and later owned by Cardinal Aeneas Silvius Piccolomini who became Pope Pius II in 1458. The stylized border design carries the Piccolomini arms.

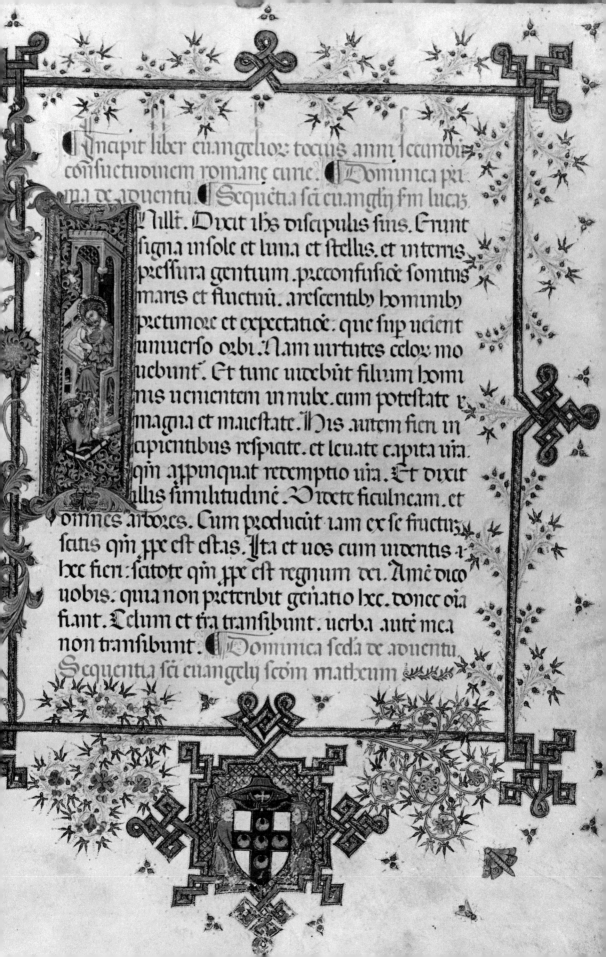

Incipit liber euangelior: totius anni secundū
consuetudinem romane curie. ¶Dominica pri
ma de aduentu. ¶Sequentia sci euāngly scm lucā.
Nillt. Dixit ihs discipulis suis. Erunt
signa in sole et luna et stellis. et in terris
pressura gentium. pre confusione sonitus
maris et fluctuū. arescentibus hominibus
pre timore et expectatione. que supuenient
uniuerso orbi. Nam uirtutes celor mo
uebunt. Et tunc uidebūt filium homi
nis uenientem in nube. cum potestate et
magna et maiestate. His autem fieri in
cipientibus respicite. et leuate capita uria.
qñ appinquat redemptio uria. Et dixit
illis similitudinē. Videte ficulneam. et
omnes arbores. Cum producūt iam ex se fructū
scitis qñ ppe est estas. Ita et uos cum uidentis a
hec fieri: scitote qñ ppe est regnum dei. Amē dico
uobis. quia non preteribit gēnatio hec. donec oia
fiant. Celum et tra transibunt. uerba autē mea
non transibunt. ¶Dominica secd̄a de aduentu.
Sequentia sci euangely scdm matheum

39 BREVIARIUM

MANUSCRIPT IN LATIN ON VELLUM /
GERMANY, 15TH CENTURY

*Bene veneris deus meus, dominus meus, filius meus — Be welcome my God,
my Lord, my Son.* — Revelationes Sanctae Birgittae VII:21

"When therefore the Virgin felt that she had already borne her child, she immediately worshipped him her head bent down and her hands clasped, with great honor and reverence and said unto him: Be welcome my God, my Lord, my Son." These words are part of the Revelations of Saint Birgitta of Sweden, a medieval mystic of force and persuasion whose writings, divinely inspired, were denounced at one time but confirmed by the Council of Basel in 1520. Living in the fourteenth century and related to the Swedish royal family, Birgitta left her native country upon the death of her husband and went to Rome. There revelations were conveyed to her, some of political, others of mystical and religious nature. In 1370 she undertook a much cherished pilgrimage to Bethlehem and it was there that "she saw with her own eyes" how it had come to pass that Mary gave birth to her son and remained a virgin. Birgitta recorded this vision in writing, and it became a turning point in the iconography of the Nativity. The Virgin, she tells us, did not bear her child in pain, no, suddenly it was lying before her within the brightest radiance as she knelt in prayer. It is from this time on, 1370 to be exact, that we possess "Birgittine nativities" in the fine arts, special iconography based on Birgitta's revelation. The earliest extant example is a mural in Santa Maria Novella in Florence, dated 1375–1385. Thereafter a host of paintings, drawings, prints testify to the popularity of her revelations.

This manuscript is an unusual example of the Breviary; it was possibly written by and for the nuns of the Birgittine convent of Maria-Maihingen, near Nördlingen in Southern Germany. Saint Birgitta had established many such convents: in her native Vadstena, in Rome where she had lived so long, in Bethlehem, in England. The miniature, not by a great artist, is an intimate portrait of the saint. She is writing under the inspiration of the angel of the Lord, who seems to be dictating into her ear. Near her are the pilgrim's staff, hat, pouch, and several of the coveted badges proudly worn by pilgrims as proof of the accomplishment of their arduous journeys. Saint Birgitta is in the costume of the Birgittine Order, which exists to this day. Her contribution to the "Christmas story," inspired by medieval mysticism and devotion, is not to be overlooked.

…num orationes amore Brigitte de tota pas-
sione domini numero quindecim in totidem psal…

…Esu xpe eterna
…dulcedo te aman-
…tium et iubilus
…mentaliter excedes
…omne gaudium et
…omne desiderium
…salus et amator
…ptorum q delicias
…tuas testatus es

…ffe cum filiis hominum propter hominem homo
factus es in fine temporum Memento omnis pre-
meditationis et intimi interni meroris que
in humano corpore sustinuisti instante salu-
berrime passionis tue tempore in divino corde ab et-
no preordinato Memento tristicie et amari-
tudinis quam in anima tempore attestante habuisti
quando in ultima cena discipulis tuis corpus tuum
et sanguine tradidisti pedes eorum lavisti et
dulciter consolando imminente eis passionem

40 NOË BIANCHI: VIAGGIO DELLA TERRA SANCTA DI IJHERUSALEME

MANUSCRIPT IN ITALIAN ON PAPER /
ITALY, POSSIBLY VENICE, CA1470

And thou Bethlehem, in the land of Judah, are not the least among the princes of Judah: for out of thee shall come a Governor, that shall rule my people Israel. — Matthew 2:6

Noë Bianchi, a French Franciscan living in a Northern Italian monastery, undertook the pilgrimage to the Holy Land from Venice to Jerusalem during the latter part of the fifteenth century. His account in diary form is a veritable guide book, and the number of extant manuscript copies as well as later printed editions testifies to its popularity and the need for such a work. Cyprus, Jerusalem, the Holy Sepulchre, Nazareth, Bethlehem and Jericho! Thereafter, through the desert sands, to the monastery of Saint Catherine on Mount Sinai, site of the Burning Bush. He minutely and eloquently described what he saw: elephants, giraffes, people, life! "I can see more people in Damascus than I can see in Paris," he wrote, a surprising admission for a Frenchman.

Earlier than Noë Bianchi of whose existence we truly know, the alleged John de Mandeville the Knight, whose existence we doubt, reported even greater travels which had taken him not only to the Holy Land but further to India with its anthills of gold dust, and to the land of Prester John with its rivers of jewels. Mandeville borrowed heavily from Marco Polo's precursors, Friar Oderic di Pardenone and Giovanni de Piano Carpini, piling fiction upon distorted facts; yet they are amusing enough to let him speak: "Bethlehem is but a little city, and it was called in old time Effrata as holy writ says, *Ecce audivimus eum in Effrata.* Toward the east end of that city is a fair kirk with many battlements and towers, and within that kirk are forty-four pillars of marble, great and fair. Also beside the choir is the place where our Lord was born, that is now full well dight and richly depainted with gold and silver and azure and other divers colours. And a little thence, is the crib of the ox and the ass. And beside that is the pit wherein the star fell that led the three kings till our Lord."

Not only is today's traveler shown all these places, but surprisingly he will recognize in the towers of the Church of the Nativity a likeness to the drawing in Noë Bianchi's manuscript, which contains 155 additional and amusing ones, many of them veritable "marvels of the East."

longho xij collône per longhezza della chiesa ch
fa quatro volte xij. che sono xlviij. colonne lequa
li sostengono il peso di sopra. Et di sottore. ella la
uozata cu pietre. La naue del mezzo sie dipinta
delle colône Insu dalla mano dritta sopra le colô
ne sono tutte gli antiche sschiatte chessi truoua
no per scripture del santo euangelio cioe liber
generationis yhu zc. Da abraham Insino alno
stro signore yhu xpo. zc. Et a man mâcha della

decta naue / e affigurato ogne Ischiatta chessi truo
ua nelleuangelio Duno euâgelista. sactu e cuz
ois jpplus baptizares zc. z molte altre ischiatte
Et e scritto Jn greco z In latino soß la porta grâ
de verso oriente la qual nõ sapie / Et Jui e figu
rato larbore chesie fuor del del costato dabraha
E sul primo Ramo sta ezechielle Nellaltro sta

41

BIBLE HISTORIÉE ET VIES DES SAINTS

MANUSCRIPT IN LATIN AND FRENCH ON VELLUM /
FRANCE, CA1300

*And Joseph also went up from Galilee . . . unto the city of David, which is
called Bethlehem. . . . And so it was, that, while they were there, the days
were accomplished that she should be delivered.* — Luke 2:4–6

In this manuscript the main themes of Christmas are arranged with compelling
continuity: arranged for the story teller, one is likely to think, since compact
rendering of Scripture in the vernacular accompanies each scene, headed by
a caption in Latin. In the first scene is the Nativity in its most traditional
form, with Mary lying abed in the manner of pre-gothic iconography and
with Joseph taking a minor part; in the second or central miniature, Joseph
seems to be observing the message to the shepherds; in the third, the Magi
are alert, anticipating, on prancing horses!

How much did the medieval stage, the mystery play of the cathedral and
church, influence not only the iconography of each scene but also the
dramatic sequence in the manuscript? Or did manuscripts like this picture
Bible influence the stage-struck clergy and laity in the setting up of their plays?
In earliest times, the priest read the Christmas story from the Gospels. Later,
a second priest joined him with the words of Christ, almost as a responsory,
and the congregation replied in chorus. This led, in the tenth century, to
the earliest "mysteries," written by the monk Tutilo in Saint Gall. Later yet,
stage properties were added: the star of Bethlehem was carried up the aisle;
the Holy Ghost was lowered from the ceiling; laymen in costume, taking
the part of the Magi, were added to the reciting priests and responding
people. Then it was decided that all this was not entirely suitable for the
interior of the church; and the "play" moved before its portals, was performed
in the market place, and was played on wheeled stages that could be taken
to any part of the medieval town. The success of such popularization of the
Christmas story, as well as of other feasts, in the dissemination of Scripture
by participation of the man in the street cannot be overlooked. Yet Christmas
and New Year's feasts developed excesses: the lower clergy aped the higher;
people drank in church, played dice, introduced the ass and the fool. The
ultimate creation of the Feast of Fools, however, allowed freedom of expression,
riddance of strangled emotions. Christmas became expression of release, joy,
as well as closer attachment to the traditional meaning of the holy days.

This picture Bible, by its very design, does invite speculation of a
connection between the medieval theatre, the mysteries, and the writer and
illustrator of books.

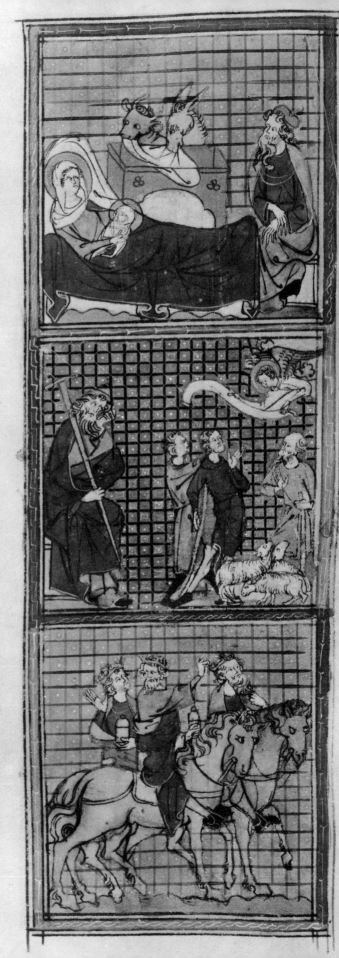

Factu est aute cu esset ꝛ ipleti
sunt dies ut parerer ꝛ peperit
filiu suu primogenitu ꝛ c. Or auint
ainsi come il estoient en bethleem
que le teps fu acompli que nre dame
dut enfanter ꝛ enfanta son fil ꝛ len
uelopa en drapeaus ꝛ por ce que la uille
estoit occupee de gens ꝛ por leur poure
te il ne porent auoir hostel por estre her
bergies en la uille. si pourchaca ioseph une
petite place ou estoit une petite esta
ble a i. beuf ꝛ a i. asne ꝛ la se retraiт
ꝛ couschierent nre ihu crist en la creche
sus le foing deles les bestes mues.

Pastores loquebant adinuicē ꝛ c.
Or estoit de coustume lors que
les pastoureaus es longues nuis dy
uer ueilloient sus leurs foues de beste.
ꝛ ainsi come cil de bethleem ueilloient
ainsi langre nref leur apput ꝛ leur
anonca la natiuite de nre sauueur
ꝛ leur enseigna ou il trouueroient
ꝛ oirent chanter les compaignies des an
ges ainsi. Gloire soit lassus u ciel a
nref ꝛ en terre puis aus homes de bone
uolente ꝛ lors il uindrent. ꝛ lors il
dirent en bethleem ꝛ trouueret ainsi
estre auenu come langre leur auoit
dit ꝛ sen retournerent loans ꝛ glorie
fians nref.

Cu nat esset ihc in bethleem iude
ꝛ c. Apres ce que nref ihucrist
fu ne en bethleem u teps que le roy
herode regnoit en galylee uez ci uenir
iij. ghis roys dorient en ihrlm qui com
mencerent a enquerre ꝛ a demander
por tout nouuelles de ceste natiuite
disoient ainsi qui nous saura a dire
ou cest que cil est nez qui est rois des iuis
Car uraiement dient il ns sauons bi
en ql est nez a enuiro car ns auons
ueu sestelle tres clere ꝛ luisant en ori
ent ꝛ pour ce somes nous uenu de moult
loing por le aourer ꝛ li offrir de nos do

42 PSALTERIUM

MANUSCRIPT IN LATIN ON VELLUM /
GERMANY, BAVARIA, 12TH CENTURY

And she brought forth her first-born son, and wrapped him in swaddling clothes, and laid him in a manger; because there was no room for them in the inn. — Luke 2:7

The scene of the Nativity developed slowly in Christian art. On the earliest ivories and sarcophagi of the fourth century the Christ child is in his manger, alone, accompanied by ox and ass only. Shepherds as witnesses of the divine birth, or prophets with scroll in hand to testify to their messianic message, appeared later. In the sixth century the steadfast, stylized, and lasting byzantine iconography allowed Mary to be present, reclining if not lying, but distant, not a major part of the composition. Joseph was added, in meditation rather than participation; above them are the manger and child, raised high as an altar symbolizing Christ's incarnation and his sacrifice. Ox and ass are present; the whole is set within a cavern, well known to people in the East, and not yet a stable. Carolingian and Ottonian miniatures tenaciously, obediently, slavishly, continued the byzantine tradition. Only slowly did it soften, additional actors enter the stage, and a more human image develop. This evolution was due to the rapid growth of the cult of Mary in the fourteenth century, and to the teaching of such men as Bernard de Clairvaux and Giovanni de Caulibus. Giotto in his Assisi mural of 1305 gave the Western world the first — and surely upsetting — deviation from tradition: Mary still abed, lovingly bends over the manger, tending to the child! After Saint Birgitta's revelations later in the century, a veritable iconographic revolution set in: the genre scene developed; symbol was piled upon symbol; scholarly exegesis upon less scholarly exposition; legend upon legend.

In the miniature of this German psalter of the twelfth century, every detail of the byzantine tradition is apparent. An interesting feature, however, has been added. Isaiah's prophetic "The ox knoweth his owner; and the ass his owner's crib" had proved ox and ass to be aware of the child's divinity, and it invited untold and eager theologians to extremes in speculation on the deeper meaning of the saying. Finally, the ass meant the Old Testament, the ox the New. Yet while the Christ child has been seen playing with them both, the ox is more often singled out for a loving pat. The ass, more interested in his "owner's crib" and attending to its fodder, is obviously not as favored. In the miniature a contest seems to have developed: the Old Testament, as it were, tearing at the swaddling clothes; the New defending the Christ child's comfort and safety.

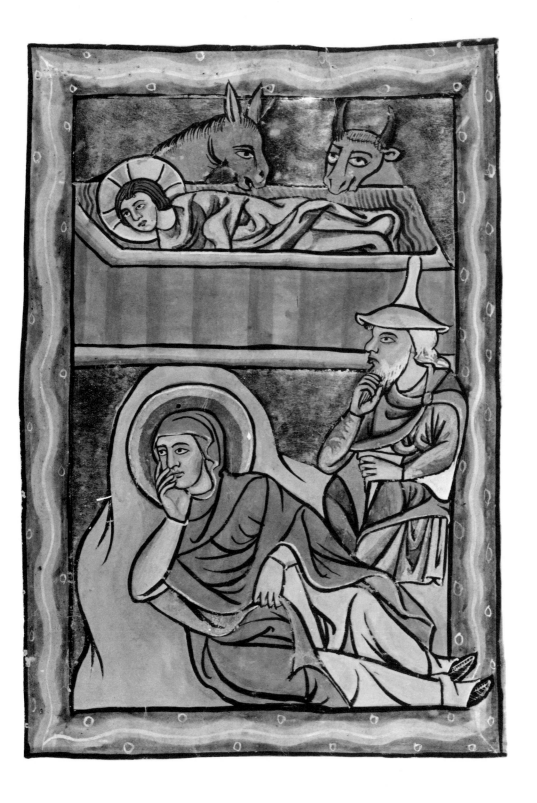

43 DOMINICALE ET MISSALE

MANUSCRIPT IN LATIN ON VELLUM /
ITALY, FERRARA, 1463

Puer natus est nobis, et filius datus est nobis, cujus imperium super humerum ejus; et vocabitur nomen ejus: magni consilii angelus. — The Third Mass of the Nativity of Our Lord

"A child is born to us and a son is given to us, whose government is upon his shoulders: and his name shall be called the angel of great counsel." Thus begins the third mass of the Nativity in the Dominican missal to be sung on Christmas day. It is not known when the feast of Christmas was fixed on the twenty-fifth of December. In the earliest days of the Church the threefold manifestation of Christ: Birth, Adoration of the Magi, and Baptism, was solemnized in the first days of January. Later, the feast was set on the present day, and fourth-century Rome and Antioch accepted this practice; it became a day of feasting and rejoicing. Previously and in those parts of the world where the sun is more desirable than rain, the solstice had been celebrated in rites and services. The general atmosphere of rebirth suggested personal birth, and since Mithra, that radiant Eastern God of Light, was honored on the twenty-fifth, it is quite possible that associations and transferences, orally transmitted, grew into acceptable belief.

In the ninth century, Notker *balbulus*, Notker the Stammerer, wrote a most stirring and spirited "sequence" in honor of Christmas day. These sequences were sung between Gradual and Missal, following the jubilant and rousing *alleluia* of the former. *Natus ante saecula dei filius invisibilis, interminus . . . ,* with voices rising to the ceiling of the chapel or choir, is first written down, with musical notations in the margins, in a contemporary manuscript still in Saint Gall, home of Notker.

It is also a variant of the text of the third mass for the Nativity which appears in this manuscript from the Spencer Collection. The large initial letter "P" — *Puer natus est* — begins the established text. Within the narrow space of the initial is an endearing scene of the Holy Family: intimate, adoring, domestic. The initial is enhanced by decoration, typical of the early renaissance school of miniature painting at the court of Duke Borso d'Este, that great bibliophile and patron of letters, who had set up a scriptorium where scribes and artists like Ercole Roberti, Franco di Russo, and Cosimo Tura worked. The manuscript, with thirty-eight additional initials and more than fifty marginal drawings, is dated 1463.

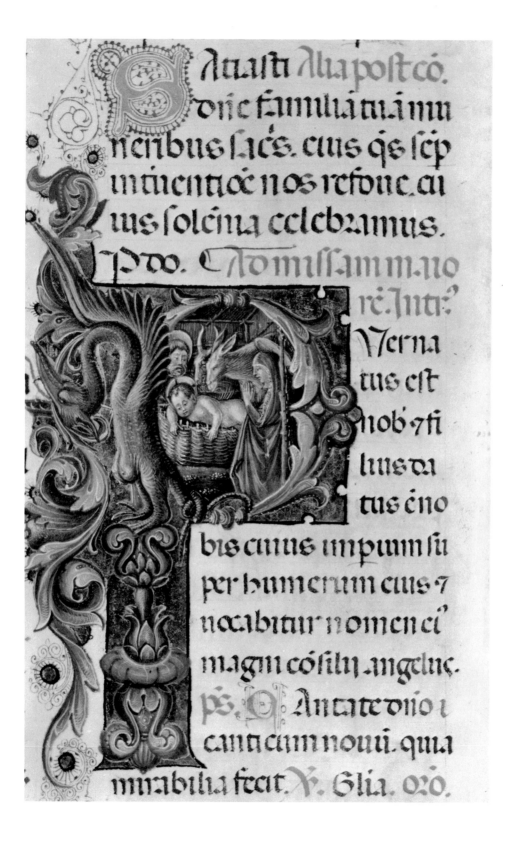

Ltasti. Alia post co.
Done familiam tuam munentibus sacs. eius qs sep intuentie nos refoue. ai ius solénia celebramus.
P oo. Ao missam m. noré. Intr.

Verna tus est nob z filius da tus éno bis cuius impium super humerum eius z uocabitur nomen ei magni consilii angelus. ps. Antate dño z canticum noui. quia mirabilia fecit. V. Glia. oro.

44 LECTIONARIUM ET SEQUENTIAE

MANUSCRIPT IN LATIN ON VELLUM /
ITALY, CA1520

Behold, a virgin shall be with child, and shall bring forth a son, and they shall call his name Emmanuel, which being interpreted is, God with us.
— Matthew 1:23

A festive renaissance manuscript, of the lessons and hymns to be sung at certain masses, shows a handsomely illuminated page, the opening of the third mass for the Nativity with a lesson taken from the Epistle of Paul to the Hebrews: *Fratres; multifariam, multique modis olim Deus loquens patribus in prophetis . . .* — God, who at sundry times and in divers manners spoke in time past to the fathers by the prophets. . . . The upper part of the miniature is taken up by a rather well-composed rendering of the Nativity, in rural setting, but with extraordinary concentration on the Holy Family. The work has been ascribed to a Roman artist, certainly Northern Italian, and surely written and designed for a person of consequence. The calligraphy has style, though not perfection, but the plaque-like frame for the whole shows imagination within the realm of renaissance imagery. The decorative border is composed of foliage, stylized and real, and within its intricate pattern the artist painted a few jewels. Within the border, *putti* play; the whole is supported by two sphinxes with the head of a woman and a lion's rump.

No longer is the manger a cave, as in byzantine and romanesque times; no longer is it inside a gothic stable; no, it has been moved under the Italian sky, sheltered by a simple canopy against excessive heat. Time stands still. Mary and Joseph, ox and ass, remain silent in the adoration of the child. In humility and wonder the parents kneel, accepting the blessing, thanking God. Soon the outside world will arrive: the shepherds will march in and the bustling midwives of legend will crave attention; the duty-bound, gift-bearing three kings from the East are already on their way. Outside, the angel of the Lord announces to the shepherds in field and village the divine message; but within the family, all is prayer and peace.

Seven similar illustrated and illuminated pages and chapter beginnings make up the manuscript of this lectionary. Its red velvet binding is studded with *nielli* of Pope Leo X, the son of Lorenzo di Medici, and of Pietro Bembo, his secretary and a great humanist.

IN NATIVITATE DOMI
NI IN TERTIA MISSA

Lectio Epistole Beati Pauli Apostoli ad Hebreos.

RATRES: Multifariam multisq; modis olim Deus loquens patribus in prophetis: nouissime diebus istis locutus est nobis in filio: quem constituit heredē uniuersorum: per qvem fecit & secula

The Shepherds in the Field

45 WINGFIELD HORAE ET PSALTERIUM

MANUSCRIPT IN LATIN ON VELLUM /
ENGLAND, CA1450

And there were in the same country shepherds abiding in the field, keeping watch over their flocks by night. — Luke 2:8

The exultation of the Holy Family was not immediately shared by the shepherds when the angel, Raphael chief of the guardian angels, announced the birth of Christ. Their reaction was bewilderment, fearfulness. And that is natural: they represent the people, unaware and only sensing potential danger to their flocks. That is conveyed when Luke says: "And they were sore afraid"; but Raphael assured them: "Fear not: for behold, I bring you good tidings of great joy, which shall be to all people."

The shepherds represent "all people" and as such are close to the artist of any period. In these pictures we find traces of realistic costume and manners even in the sarcophagus reliefs, the ivories, and in the miniatures of early art: the Roman girdled tunic, the Perso-Phrygian cap, the staff, the water bottle, the tools of their trade. After the budding of Franciscan piety, and when the Bible was no longer used to expound words but to stir people's hearts, we meet the shepherds more relaxed, participating, joyfully accepting the miracle. Seen at a distance in representations at first, they are soon on their way to pay homage to the child; adding human, almost comic, touches, they crowd in the doorway; they peep through windows from the outside; they humbly, shyly, but also curiously, present their gifts.

This miniature from the English Hours and Psalter shows the shepherds in an imaginary rural setting, eerie and forbidding. A small shed in the background for the sheep. Shielding his eyes from the blaze of light, a shepherd perceives the angel in the sky: *gloria in altissimis deo*, while his companions breathlessly watch for his report. His is the costume of the English working man, sturdy, functional. In the background a small bridge leads to a fortified mansion of the time of the War of the Roses, the time of Henry VI and Edward IV. Also the time when the manuscript's first owner, Humphrey, 7th Baron and 6th Earl of Stafford, created Duke of Buckingham in 1444, gave it to his wife, Lady Anna Neville, daughter of Ralph, 1st Earl of Westmoreland. Her name appears in one of the prayers: *ut avertas iram tuam a me famula tua anna.* It is a splendid book with twenty-eight miniatures, evocative, forceful. Their margins are filled with the wonders of England's late medieval imagination.

Deus in adiutozui meu inte
de. Dne ad adiuuandu me
festina. Gloria pa. hnus
eu cratoz sps men
tes tuoz iusita imple
supna gra que tu craisti pctoza Memento
salutis aucto: qd nri quondam rozpozis ex ti

46 HORAE BEATAE MARIAE VIRGINIS

MANUSCRIPT IN LATIN ON VELLUM / FRANCE,
NORMANDY OR BRITTANY, 15TH CENTURY

Glory to God in the highest, and on earth peace, good will toward men. — Luke 2:14

In medieval legends Christmas Eve is filled with miracles. Following Saint Bernard's and Saint Birgitta's expositions, the story of the Nativity gathered additional imagery and the legends were multiplied and popularized. The vineyards of Jerusalem flowered and bore fruit; a Roman spring turned into oil and flowed into the Tiber; to the Emperor Augustus appeared the Tiburtine Sibyl pointing towards a king in heaven "who will be greater than you"; and three suns arose in the East, fiery and radiant, and were taken to represent the Holy Trinity. According to Saint Chrysostomos, the golden tongued, the star seen by the shepherds was the image of the Christ child; and tradition placed Saint Jude the Apostle and Saint Simon the Zealot among the shepherds. In medieval England a sheep was led in the Christmas procession, to commemorate the shepherds' visit.

A fourteenth-century miracle play, written by "the monks" of Widkirk Abbey and played by the tradespeople of Wakefield in the County of York, is a delightful mixture of Bible and banter, Christmas and the world! It is played by a number of shepherds "in the field," hardly enjoying the rudeness of the winter: "Lord, what these weders ar cold, and I am ylle happyd; I am nere-hande dold, so long have I nappyd," or the unexpected arrival of a neighbor of ill repute, known for his thievery. When they are ready for sleep, they make the suspect lie between them; but of sleep there is none until Mary appears, telling of the birth of her son: "He kepe you fro wo: I shalle pray him so." The play ends in an outburst of good faith and cheerfulness.

The manuscript miniature here conveys some of this cheerfulness. The shepherds salute Raphael like an old and familiar friend; the sheep are unconcerned; the world seems at peace. Not so the marginal illustrations and their deeper meaning, invented perhaps and painted by an unknown and unskilled hand in either Normandy or Brittany in the fifteenth century. With its repeated mottoes *je me plains a raison, espoir me*, its many drolleries, unpleasant and sinister, and its often appearing initials "G M" with a skull, the pocket-size manuscript, one is tempted to suppose, may have been made for a prisoner, for someone who suffered great injury, or possibly for one of the nobles disgraced by Louis XI. A prayer in the vernacular *donne nous misericorde mon sauveur* is in keeping with the text to the "shepherd miniature": *Deus, ad adiutorium meum intende* — O God, come to my aid.

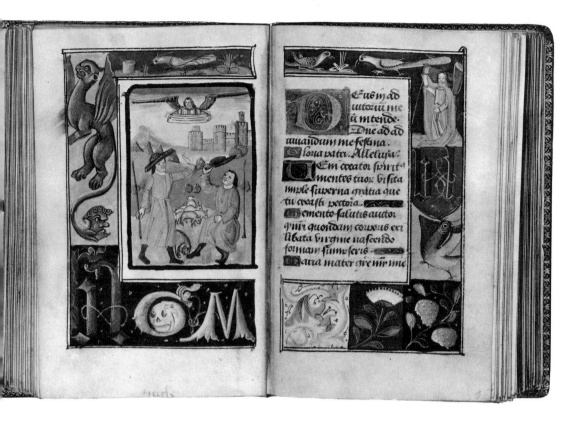

eus in ad
iutoriu me
u intende.
Dne ad ad
uuandum me festina.
Gloria patri. Alleluia.
Em creator spiritus
mentes tuor visita
imple superna gratia que
tu creasti pectora..
emento salutis auctor
qm nri quondam corporis ex-
libata virgine nascendo
formam sumpseris.
aria mater gre mr une

47 LEBEN CHRISTI

MANUSCRIPT IN GERMAN ON PAPER /
GERMANY, 1440

And there came a great tumult in Bethlehem of Judaea; for there came wise men, saying: Where is he that is born king of the Jews? for we have seen his star in the east and are come to worship him. — Book of James or Protoevangelium XXI:1

The visit of the Magi represents Christ's first presentation to the gentiles and it is celebrated by the Church on January sixth, ecclesiastically called Epiphany, popularly Twelfth Night. In one instance, gold, frankincense and myrrh are offered in the Royal Chapel of Saint James's Palace on behalf of the sovereign; a Twelfth Night cake, a bean hidden in it, proclaims the finder King of the Bean and a lucky man. Twelfth Night brought all of Christmas to a hearty conclusion.

"When Christ was born," to quote the Golden Legend, "three Magi came to Jerusalem. In Greek their names are Appellius, Amerius, and Damascus; in Hebrew, Galgalat, Malgalat and Sarachin; in Latin Gaspar, Balthasar, and Melchior. . . . *magus* means the deceiver, the magician, the wise man. . . . For it is a Persian word, and in Hebrew means a scribe, in Greek a philosopher, and in Latin, *sapiens*, that is, wise man." More seriously, the Magi are considered to have come from Persia, from Mesopotamia, from the East!

Having heard of the birth of Christ and seen the guiding star in the sky, the Magi readied themselves to be on the way: Matthew speaks of three kinds of gifts, establishing the conception that there were three; yet an Arian legend of the fourth century speaks of twelve magi or kings. In those fabulous cave churches of Göröme in Cappadocia, in a tenth-century fresco, six magi bow low before the Madonna and Child. Even the Psalmist refers to four when he speaks: "The kings of Tarshish and of the isles shall bring presents: the kings of Sheba and Seba shall offer gifts."

Melchior der kunig von India und Arabia der was der erst mit seinem Volckh — Melchior, king of India and Arabia, with his retinue, arrived first, according to this very popular German manuscript, mixing scripture, legend, and 256 amusing but crudely drawn pen and ink sketches, for the delectation of its fifteenth-century readers. Over mountains and through valleys of unknown lands the kings must travel to convey the perils of such a journey. However, they must travel in style as befits the medieval tradition, and a veritable royal progress is the consequence. In the lower illustration, Melchior greets Balthasar on Mount Calvary in Jerusalem; they have arrived at last and will soon be in the presence of the child.

Elchior der kunig von Judea und Arabia
da was der ast mit seinem volckh und cham
zu dem perg Caluarie auff den ha nach
xpus gefurt ward und gemartert Also pelaib
er in dem nept auff dem perg

Hie cham der kunig Balthasar auch mit seine
volckh ein andre strazz auff den perg Caluarie

48 PSALTERIUM

MANUSCRIPT IN LATIN ON VELLUM /
GERMANY, BAVARIA, 12TH CENTURY

Now when Jesus was born in Bethlehem of Judæa in the days of Herod the king, behold, there came wise men from the east to Jerusalem. — Matthew 2:1

Epiphany, manifestation of a divine being, had meant Incarnation in early Christianity, and the birth of Christ, the Adoration of the Magi, and Christ's baptism were celebrated together upon one occasion. Only after the fourth century did both the Eastern and the Western Church decide on the date of the Christmas feast as we know it today. Then, the Epiphany became the feast of the Epiphany of Our Lord, recalling Matthew's "star, which they saw in the east," which brought to pass Isaiah's prophecy: "Arise, shine; for thy light is come, and the glory of the Lord is risen upon thee."

As early as the third century, representations of the Adoration of the Magi had been part of Christian art. While the scene, the grouping, the composition, underwent fashionable changes throughout the centuries, in essence the event is unmistakably recognizable whether one enjoys a fourth-century stone relief, a byzantine ivory, or an Ottonian miniature. Whatever change there is, it is change in technique: sculpting, carving, painting. The scene on the Clipeus sarcophagus in the Lateran, the mosaic in Sant' Apollinare Nuovo in Ravenna, and Trier's tenth-century Egbert codex testify to the longevity of its almost unchanged iconography. It is only in the Middle Ages and the Renaissance that variations appear: these range from static, majestically grouped persons in austere, symbolic surroundings to the most outrageously extravagant settings and costumes of the richest Oriental splendor. It is the range from Giotto, from *Les Trés Riches Heures du Duc de Berry*, to the most elaborate, almost foppish, representations of the late Flemish masters.

Legend has it that the empress Helena, that indefatigable traveller, had come upon the relics of the Magi in the Orient, and that she had them transferred to the city of her emperor-son, Constantinople. Legend also reports that the Milanese bishop Saint Eustorgius had them brought from Constantinople to his home town; near Milan they were discovered by the emperor Barbarossa in 1164, and it was he who had transferred the sacred relics to Cologne Cathedral. There, a shrine was fashioned by master Nicolas of Verdun in the twelfth century, a masterpiece of the goldsmith's art. Of the twelfth century also is the miniature of this Spencer Collection psalter. Set against a background of solid gold, the actors stand out like flaming design in a stained glass window. In the order of their age and station, the Magi present their gifts: gold, incense, and myrrh — that is, King, God, and Man.

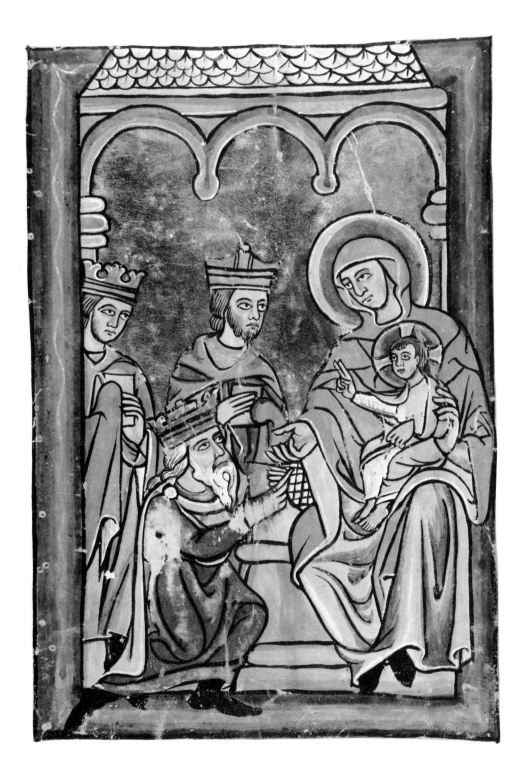

49 DE LA TWYERE PSALTER

MANUSCRIPT IN LATIN ON VELLUM /
ENGLAND, CA 1320

And when they had opened their treasures, they presented unto him gifts; gold, and frankincense, and myrrh. — Matthew 2:11

Thirteen leaves, with four miniatures each, introduce the Latin psalter written and illuminated for William De la Twyere of Preston in the early fourteenth century. It is a forceful and direct set of scenes from Old and New Testament; not from the finest hand but of character and immediacy. In the tradition of the time, the personages of the miniatures are in generally accepted semi-biblical costume, though with traces of contemporary realism and touches of the fashions of the fourteenth-century courts. In the upper sequence Mary with her great coat and veil could be any queen ready to sweep through the royal apartments; the Three Holy Kings in gowns of semi-clerical character worn by legal dignitaries and men of government are the artist's contemporaries. All these are set against backgrounds of solid gold or stylized diaper pattern; the illuminator is not yet of the time when artists introduced more realism in background and landscape. Lovingly, Mary gives the infant her breast, but — as a realistic touch — the child, accepting her grace as a matter of course, already has stretched out his hands towards the gifts that have come his way. The Magi are stately men, aware of the significance of the moment. The oldest kneels, a crown on his knee; the others, in lively agreement, are pointing to the star that had led them here so safely.

The sequence of scenes is by no means of typological significance as it would be in a typical "moralized Bible" of the Middle Ages. There, the Adoration would have been flanked by Abraham offering gifts to Melchizedek or the Queen of Sheba presenting gifts to King Solomon. In this manuscript, however, the sequence or grouping was meant to present biblical events as a general preparation to the reading of the Psalter, not unlike murals in a church, a cloister, a vaulted cemetery.

Had the artist of the De la Twyere Psalter read the Golden Legend? "Entering the manger, and finding the Child with His mother, the Magi fell to their knees and adored Him: and opening their treasures, they offered Him gifts, gold, frankincense, and myrrh among the ancients it was the custom never to present oneself before a god or a king without offering gifts; and the Wise Men, who came from the country of Persia and Chaldea, where the river Saba flows, brought the gifts which the Persians and the Chaldeans were wont to offer."

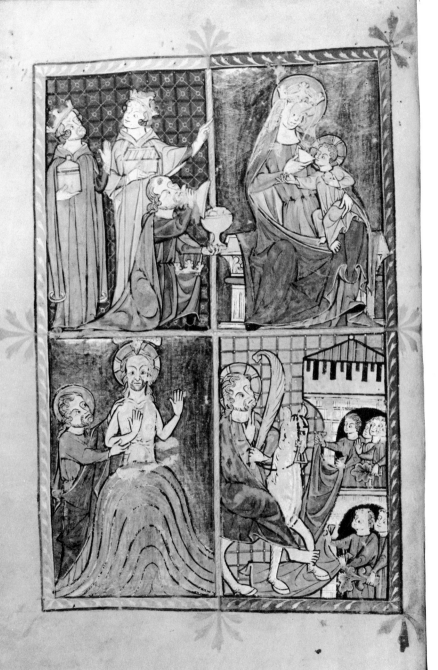

50 SPECULUM HUMANAE SALVATIONIS

MANUSCRIPT IN LATIN ON VELLUM /
NORTHERN GERMANY OR THE NETHERLANDS, CA1410

And, lo, the star, which they saw in the east, went before them till it came and stood over where the young child was. — Matthew 2:9

Legends of the Magi followed Scripture rather accurately. The Magi, so we learn, were not men who knew the arts of magic better than others, but wise princes of an Eastern land. The prophecy of Balaam, so legends insist, had been well remembered by their people: "there shall come a Star out of Jacob, and a Sceptre shall rise out of Israel." When the Magi saw a star so different from those they had known as astronomers, they recognized that it had deep meaning and prophecy. And they followed it at once. This scene had often been the subject of rather unusual representations in Christian art: Rogier van der Weyden, for one, inspired by the Golden Legend, painted the medieval Bladelin Altar with the star in the shape of a small child!

The *Speculum Humanae Salvationis* or "mirror of human salvation," a manuscript in the Spencer Collection with 194 colored drawings from about 1410, has "Christ Carrying His Cross" within the star message to the Magi: *hoc signum magni regis est.* A lively discussion by the Magi follows, and presently we find them in adoration of the Christ child, the star "over where the young child was." The manuscript, one of the many typological medieval works was probably written and illustrated by monks from Northern Germany or the Netherlands. At one time it was in the possession of one Johann Wassenbergh of the Abbey of Sankt Odilienberg near Strasbourg. In this book the star of the Magi had become the symbol of "human salvation."

Earlier, when Gregory Nazianzus, one of the great Eastern and Cappadocian fathers, wrote his Christmas *oratio* in the fourth century, the star was the main theme of the oration. But further away and halfway round the world, its fame had spread to China's Si-an, where it is inscribed on a seventh-century stone Nestorian "Monument of the diffusion through the Middle Kingdom of the Brilliant Teaching of Ta-Ch'in" — Ta-Ch'in being the Chinese name for the Near East here referring to the place from where Christian teaching had come. There, the inscription reads: "Upon this the divided Person of our Three in One, the brilliant and reverend Messiah . . . came to earth in the likeness of man. An angel proclaimed the good news; a virgin gave birth to the sage in Ta-Ch'in. A bright star told of good fortune; Persians saw its glory and came to offer gifts."

Tres magi

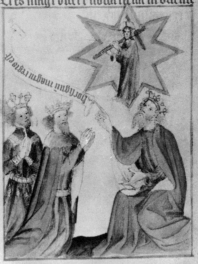

Capitlm IX

In precēenti capło audiuimus de xp̄i ge-
neratōe Cōsept audiam⁹ de magoʒ ob-
latōe Eade die cū xp̄c ī iudea eēt natu-
ro ᵼus et ᵼbʒ magis ī oriēte ᷑ nūciatus
viderūt nāᵼ stellā nouā ī ꞯ puer apa-
rebat Sup cui⁹ caput crux aurea splen-
debat Audierūt ꞯ vocē magnā dicēte sibi
Ite ī iudea ᵼ nouū regē iuēietis ibi Tres
isti festinātes ī iudeā pgebāt Et regi celi
nato sua munia offerebāt Hij tres magi
per tres robustos pfigati fuerūt Qui re-
gi dauid aquā de cisterna bethleem attu-
lerūt Istoʒ robustoʒ vᵼtus ᵼ audatia milᵼ
omendat Sic magoʒ Aduētus ᵼ oblatō
valde apbat Tres robusti exᵼcitū iīmicoʒ
nō timuerūt Sʒ viriliᵼ castra eoʒ tr͂seūt͂
aꝗ hauserūt Sicut tres magi potēciā hero
dis nō formidauerūt Sʒ audacter iudeam
i͂rātes de nouo rege ī͂rogauerūt Iaspar
balthasar melchior noīa sꞥ magoʒ Elyᵼ
sai sobothai balchhas noīa robustoʒ
Tres robusti piererūt bethleem pro aꝗ
cysterne Tres magi venerūt bethleem
pro aꝗ gr͂e esᵼue Tres robusti hauserūt
aꝗ de cysterna firebri Tres magi suscepe
rūt aquā de patria celesti figurabatur
ergo illa bethleemiticꝭ cystina ꝙ bethlee

nasciturus eēt celestis pīncᵼra Qui pꝓiam
aꝗ gⁱe oī sicienti Et daret gratis aquam
vite nō hūti dauid rex aꝗ oblatā dō pⁱo
gr͂z actōe offebat Gaudeᵼ exultās ꝙ tam
robustos viros hēbat Cristus aūt rex cⁱh ᵼ
tᵼe gaudebaᵼ ᵼ exᵼabat Qⁱ aduēt⁹ magoʒ
ꝗ͂sione gēciū pfigabat dauid rex nō videᵼ
aꝗ siᵼisse sʒ suoʒ suoʒ vᵼtute Xp̄c viderᵼ siᵼisse
nr͂am ꝗ͂sione ᵼ saluteᵼ Tres robusti bethleᵼ
breui tp͂e ᵼ hora piererᵼt Tres magi de oriēte
breui tp͂e bethleem pueneᵼt Si qⁱ r͂at quō t͂a
tū spariū tam cito potuerūt t͂smeare dice
dū ꝙ xp͂o nato nō ipossibile fuit hec dare
Qui eduᵼit abbacuc subito de iudea ī babilo
nē ᵼ cito pduce potuit de oriēte ī iudeoʒ re
gione Venietes igitur magi bethleem cor͂a
pꝓ procidebāt ᵼ aurū thus et mirram ei
offebant Figura hui⁹regis noui et hui⁹
oblatoīs pⁱmiata fuit olim ī regno regis
salomonis Salomon rex licet puer esset
tⁱ sapientissim⁹ fuit Deus puer ētus nō mi
nus sapiēs ꝗ antea extᵼtit Salomon rex re
sidebat in throno de ebore mūdissimo Qui
vestᵼius erat auro optimo et mūdissimo
Vniuersi reges terre regē salomonē vide
desiderabant Et ei munera preciosa et ca
rissima portabant Sed regina saba tāta

51 HORAE BEATAE MARIAE VIRGINIS

MANUSCRIPT IN FRENCH ON VELLUM /
FRANCE, 15TH CENTURY

And when they were come into the house, they saw the young child with Mary his mother, and fell down, and worshipped him. — Matthew 2:11

Did the courtiers of Charles VIII or Louis XII arrive with gifts to a young woman in a village of Normandy? So worldly appears the scene in setting and dress that the thought springs to mind unwittingly. The manuscript was written and illuminated by an artist of the Northern school of painting towards the very end of the fifteenth century, and its text is in the vernacular, translated from the Latin. Fifty years earlier the great masters of the miniature, Jean Colombe, Jean Bourdichon, Jean Fouquet, had dared, successfully, to innovate the representation of biblical persons and times in contemporary dress, accoutrements, and detail. It must have seemed outrageous! This prayer book in the Spencer Collection is no exception to the trend which was to bring the Bible closer to the people, to attract and hold their attention, and please their vanity in proprietorship. Marginal drawings had become so worldly that decrees were issued to omit them lest her ladyship's attention be diverted from the required texts. But what was wrong in having men and women, in painting and in miniature, act and look as if the artist had just seen them walking in the avenues and gardens of the Quartier du Marais?

The manuscript with its thirty-eight full-page miniatures is not an uncommon product of the fifteenth century. Its range of imagery, particularly in the elegant and worldly scenes that accompany the twelve pages of the calendar, is considerable. As a whole it has unity of design, and it represents the proud property of a man of some taste and standing, for by this time the printing press was turning out hundreds of copies in letter press and woodcut, often based on manuscript models. The Magis' style, grace, and reserve harmonize well with the child in Mary's lap. How beautifully the Evangelist speaks: "they saw the young child with Mary his mother, and fell down, and worshipped him."

52 PSALTERIUM

MANUSCRIPT IN LATIN ON VELLUM /
ITALY, NAPLES, 15TH CENTURY

*And when the days of her purification . . . were accomplished, they brought
him to Jerusalem, to present him to the Lord . . . And to offer a sacrifice . . .
A pair of turtledoves, or two young pigeons.* — Luke 2:22–24

The purification of the Virgin and the presentation of Jesus in the Temple,
based on Scripture, are often combined in iconography. The Mosaic law
forbade the mother of a man-child access to the sanctuary for thirty-three
days. Thereafter she presented a lamb as a sacrifice or, in the case of extreme
poverty, two turtle-doves. But the day of purification also meant the child's
acceptance by the high priest. Legends tell us that Simeon the Prophet
found his release from God's command on that day. Simeon, one of the
learned rabbis engaged in the translation of the Bible from Hebrew into
Greek at the command of the Pharaoh in 260 BC, had doubted Isaiah's words:
"Behold, a virgin shall conceive and bear a son" and had substituted "young
woman" for "virgin," only to find his translation erased by the angel of the
Lord. Three times this happened, when God's purpose was revealed to
Simeon and he learned that he should not see death until all had been
fulfilled. On that day of the Presentation, he recognized the Redeemer and
was allowed to depart: *Nunc dimittis servum tuum* — Now lettest thou thy
servant depart in peace.

One of the earliest Presentation scenes is within Santa Maria Maggiore's
brilliant mosaic of the fifth century: Mary is the *theotokos* in empress'
mantle and tiara; the child wears the byzantine tunic and pallium. Later,
the purification offering, the doves, are stressed: symbol of Noah, Moses,
the Temple, the Holy Ghost. From the tenth century onward the Presentation
becomes a feast of light, *festum candelarum*, the blessing of candles.

This miniature from the Neapolitan psalter shows the presentation of
Jesus, more than it does the purification of the Virgin. Turtledoves are in
the hands of Joseph, and while Simeon, that wonderful man, is missing,
Anna the prophetess is present holding a scroll: *Ecce positus est* — Behold,
this child is set for the fall, and rising again of many in Israel. The miniature,
still and stately, is one of eight in a small psalter, written and illuminated
by Matteo Felice, who had worked for the Aragonese kings of Naples. The
tale is simply and refreshingly told in contrast to Southern Italian exuberance.
In dress and vestment there is a contemporary touch; the Temple, indeed,
might have been any chapel of the many churches in Naples.

53

MISSALE

MANUSCRIPT IN LATIN ON VELLUM /
ITALY, BOLOGNA, 15TH CENTURY

Then Herod, when he saw that he was mocked of the wise men, was exceeding wroth, and sent forth, and slew all the children that were in Bethlehem.
— Matthew 2:16

Ex ore infantium — Out of the mouths of infants and sucklings, O God, thou hast perfected praise because of thy enemies. This is the beginning of the Mass of the Holy Innocents, here introduced by an historiated initial letter "E" in a missal from the Spencer Collection. The manuscript is an elaborate illuminated production of the Bologna school of the late fifteenth century and the illuminator's name Bartolomeo Bossi appears several times within the many decorative borders. With its forty-eight initial letters on almost solid gold backgrounds, the missal suffers from a slight touch of pretentiousness. And true: it was written and illuminated and gilded for a patron and a purpose. A remark at the end, *tempore di Galeacci Marescotti*, reveals the donor who had lived to be ninety-four, and is considered to have been a rather corrupt city official. To atone for his sins, perhaps, the missal was commissioned and *in christi nomine et beati petronii* presented. Saint Petronius, bishop of Bologna in the fifth century and its patron saint, is best remembered for the *riproduzione fidele* of the Holy Sepulchre which he ordered to be constructed within the Chiesa del Santo Sepolcro, and part of the Basilica di Santo Stefano built in the fourth century. His body rests below the extraordinary monument; it has never been seen without a few flowers lying before it.

When Herod saw "that he was mocked by the wise men," he was "exceeding wroth" and ordered the massacre of the first born. Yet the Holy Family, warned by the angel of the Lord, was already on its way to Egypt. Herod's unbelievably extreme jealousy and unspeakable brutality is reported by Luke. The early Church saw in the innocents the earliest martyrs. In medieval mystery plays, Herod races into the church, ranting and raving that a King of Kings has been born into the world; using foul language, at times with special dispensation; belaboring the clergy; throwing a spear at the choir; and being in his maledictions, the element of "comic relief." The Feast of the Innocents, however, has the full privileges of a martyr's day, and is often celebrated in purple with penitential rites.

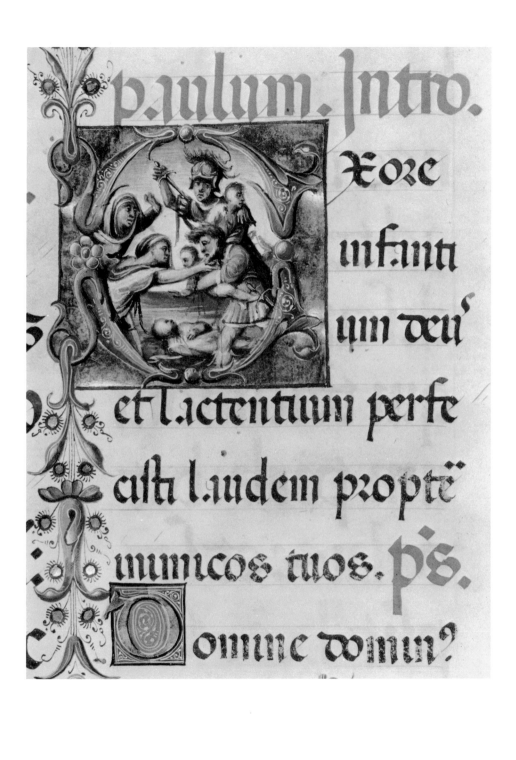

Xore

infanti

um deus

et lactentium perfe

asti laudem propte

inimicos tuos. ps.

Omine domin?

The Flight into Egypt

54 PSALTERIUM

MANUSCRIPT IN LATIN ON VELLUM /
ITALY, NAPLES, 15TH CENTURY

And when they were departed, behold, the angel of the Lord appeareth to Joseph in a dream, saying, Arise, and take the young child and his mother, and flee into Egypt. — Matthew 2:13

The Flight into Egypt is part of the Christmas story and lends a happy ending to potential danger. Artists from the earliest time to this day have lavished attention and imagination on it. This miniature from the Neapolitan psalter in the Spencer Collection combines two distinct events: the angel's warning Joseph in a dream to flee into Egypt — *Surge, et accipe puerum, et matrem ejus, et fuge in Aegyptum* reads the angel's scroll, as reported in Matthew — and the flight proper, with Mary, the Christ child, Joseph, and the ass led to safety by another angel. The many legends, told and painted, testify to the popularity of the event: the repose of the family during the flight; the palm tree that is shading them; the fig tree that bent down to give sustenance to the child; the robbers that gave shelter; the gipsy that foretold fortune; and finally the Fountain of Mary from which sprang the freshest water, and which is being shown to travellers near Cairo to this day! The most felicitous legend, however, is that of the "field of wheat." Herod had dispatched his bailiffs after the fugitives. The Virgin, seeing a man sowing, spoke: "should anyone ask for us, tell him the truth, that you saw us at the time of sowing." In a flash and a miracle the seed grew and ripened ready for the harvest. When the bailiffs passed, they received that truthful answer. They turned, thinking that the fugitives had passed a long time previously.

The eighty-first psalm; *Exsultate Deo adjutori nostro* — Sing aloud unto God our strength . . . , beneath the psalter's miniature introduces the Feast of the Tabernacle. Within the bottom margin is a small portrait vignette of King David with a small portable chamber organ, known as a *portative*, which enjoyed enormous popularity in the earlier days of the Renaissance. The manuscript's illuminator, Matteo Felice of Naples, gave his loving attention to the manuscript psalter's eight miniatures, all from the life of Christ. The three travellers in this peaceful miniature are free from danger, and our hearts are at ease.

uerte nos: et onde facie tuá et saluí erim9.

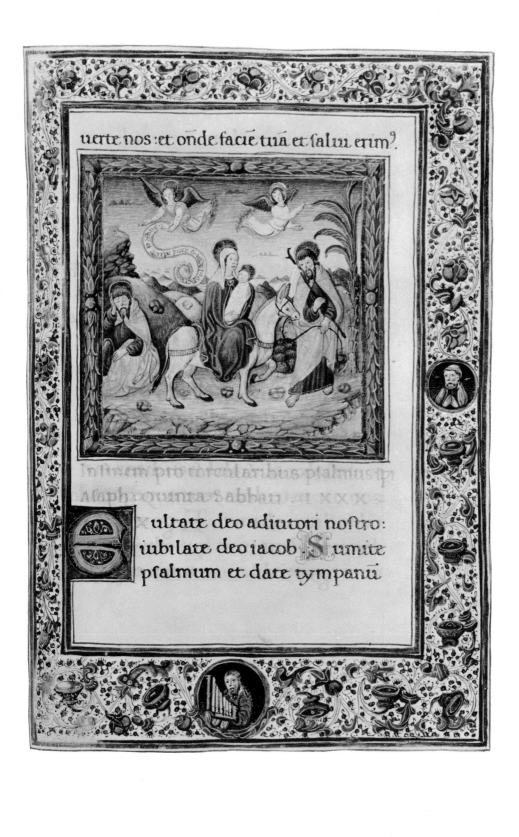

In finem pro torcularibus pfalmus ipi
Afaph quinta Sabbati. xxxx

xultate deo adiutori noftro:
iubilate deo iacob fumite
pfalmum et date tympanú

55 WINGFIELD HORAE ET PSALTERIUM

MANUSCRIPT IN LATIN ON VELLUM /
ENGLAND, CA 1450

A garden inclosed is my sister, my spouse;
a spring shut up, a fountain sealed.

The *hortus conclusus*, the Garden Enclosed, is one of the many symbols for the Immaculate Conception and as such closely linked to the Christmas story. It is also closely linked, if not based, on the exalted, Oriental love poetry of the Song of Songs, the Canticle, the Song of Solomon. How powerful, imaginative, and articulate is the poet when he speaks: "Come with me from Lebanon, my spouse, with me from Lebanon; look from the top of Amana, from the top of Shenir and Hermon, from the lions' dens; from the mountain of the leopards. Thou hast ravished my heart, my sister, my spouse."

The Garden Enclosed was an extremely well-known image to medieval man, recalling the "Golden Gate" of Anna and Joachim; the "Gate of Paradise" in the person of Mary; the "Gate that was Shut" in Ezekiel's prophecy. However, the Gospels and the many pseudo-gospels do not mention this peaceful image, directly or by interpretation. A recent discovery in Milan's Biblioteca Ambrosiana of a seventh-century pseudo-John *Evangelium*, written in Arabic, contains an interesting passage. Recapitulating many of the apocryphal events in the life of the Virgin and of Christ, it mentions the cave and not the stable; it makes much of Mary's alleged guilt; it puts her to the test according to Hebrew custom and, when she appears within an aureole of dazzling splendor, puts her accusers to shame. But more significant and here possibly for the first time, we read that the Christ child himself testified to the Immaculate Conception, His Divine Birth, His Incarnation.

Puer natus est nobis,
et filius datus est nobis,
cujus imperium super humerum ejus,
et vocabitur nomen ejus,
magni consilii angelus.

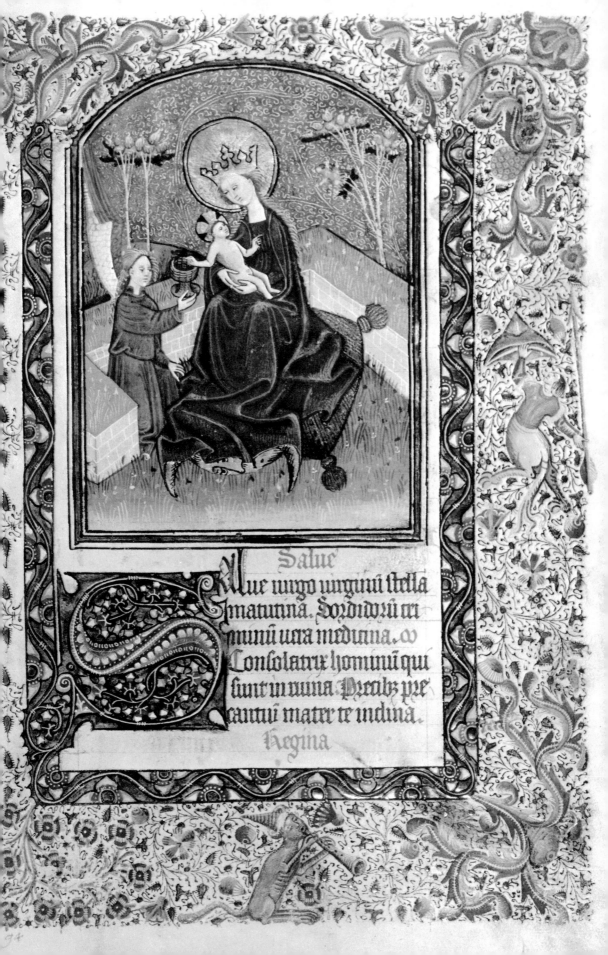

Salue

Alue virgo virginum stella
matutina. Sordidorum cri
minum vera medicina. co
Consolatrix hominum qui
sunt in ruina. Precibus pre
cantum mater te inclina.

Regina

The Manuscripts

This is a list of the manuscripts, together with their shelf numbers in the Spencer Collection of The New York Public Library:

Cover and title page: *Bible Historiée et Vies des Saints*. France, ca1300. MS 22
Initial letter: *De la Twyere Psalter*. England, ca1320. MS 2

1 Rudolf von Ems: *Weltchronik*. Germany, 1402. MS 38
2 *Gospel according to Saint Luke*. Russia, 15th century. Slavonic MS 1
3 *De la Twyere Psalter*. England, ca1320. MS 2
4 *Liber Genesis*. Germany, ca1470. MS 52
5 *Biblia Pauperum*. Germany, ca1420. MS 35
6 Ishaq ibn Ibrahim: *Tales of the Prophets*. Persia, 1577
7 *Bible Historiée et Vies des Saints*. France, ca1300. MS 22
8 *Psalterium*. Germany, 12th century. MS 11
9 *Les Heures de Blanche de France*. France, 1350–1360. MS 56
10 *Psalterium Graece*. Byzantium, ca1300. Greek MS 1
11 *Synaxarion of the Coptic Church*. Egypt, 17th century. Coptic MS 3
12 *The Tickhill Psalter*. England, ca1310. MS 26
13 *Biblia Latina*. Italy, 13th century. MS 25
14 *Biblia Latina*. France, ca1250. MS 77
15 *Bible Historiaus ou Hystoires Escolastres*. France, 15th century. MS 4
16 *Bible Historiée et Vies des Saints*. France, ca1300. MS 22
17 *Officium Beatae Mariae Virginis*. Italy, ca1500 MS 45
18 *The Bible in Hebrew*. Germany, 1294. Hebrew MS 1
19 *Bible Historiaus ou Hystoires Escolastres*. France, 15th century. MS 4
20 *Prophetae Minores et Acta Sanctorum*. Germany, ca1255. MS 1
21 *Speculum Humanae Salvationis*. Northern Germany or the Netherlands, ca1410. MS 15
22 *Officium Beatae Mariae Virginis*. Italy, ca1500. MS 45
23 *Horae Beatae Mariae Virginis*. Netherlands, 15th century. MS 36
24 *Service Book of the Armenian Church*. Armenia, 1489. Armenian MS 2
25 *Missale*. Germany, 15th century. Manuscript Division: MS 112
26 *Officium Beatae Mariae Virginis*. France, ca1375. MS 49
27 *Leben Christi*. Germany, 1440. MS 102
28 *Synaxarion of the Coptic Church*. Egypt, 17th century. Coptic MS 3
29 *La Vie de Jesus*. France or Flanders, 15th century. MS 79
30 *Bible Historiée et Vies des Saints*. France, ca1300. MS 22
31 *Officium Beatae Mariae Virginis*. France, ca1375. MS 49
32 *Ons Vrouwen Getijde*. Netherlands, 1450. MS 152
33 *Horae Beatae Mariae Virginis*. France, 15th century. MS 6
34 *Wingfield Horae et Psalterium*. England, ca1450. MS 3
35 *Bible Historiée et Vies des Saints*. France, ca1300. MS 22
36 *The Archangels Gabriel and Raphael*. Ethiopia, 18th century. Ethiopic MS 5

37 *The Four Gospels.* Russia, 15th century. Slavonic MS 2

38 *Lectionarium Evangeliorum.* Italy, 15th century. MS 29

39 *Breviarium.* Germany, 15th century. MS 63

40 Noë Bianchi: *Viaggio della Terra Sancta di Ijherusaleme.* Italy, ca1470. MS 62

41 *Bible Historiée et Vies des Saints.* France, ca1300. MS 22

42 *Psalterium.* Germany, 12th century. MS 11

43 *Dominicale et Missale.* Italy, 1463. MS 61

44 *Lectionarium et Sequentiae.* Italy, ca1520. MS 7

45 *Wingfield Horae et Psalterium.* England, ca1450. MS 3

46 *Horae Beatae Mariae Virginis.* France, 15th century. MS 10

47 *Leben Christi.* Germany, 1440. MS 102

48 *Psalterium.* Germany, 12th century. MS 11

49 *De la Twyere Psalter.* England, ca1320. MS 2

50 *Speculum Humanae Salvationis.* Northern Germany or the Netherlands, ca1410. MS 15

51 *Horae Beatae Mariae Virginis.* France, 15th century. MS 6

52 *Psalterium.* Italy, 15th century. MS 130

53 *Missale.* Italy, 15th century. MS 64

54 *Psalterium.* Italy, 15th century. MS 130

55 *Wingfield Horae et Psalterium.* England, ca1450. MS 3

Acknowledgement is made to the following authors, translators, and publishers for the use of material quoted in the descriptions:

W. H. Auden "The Play of Daniel" (Decca Record, DL 9402 1958); F. L. Cross, ed *The Oxford Dictionary of the Christian Church* (London, Oxford University Press 1957); Jack Finegan *The Archaeology of World Religions* (Princeton, N J, Princeton University Press 1952); Malcolm Letts *Mandeville's Travels: Texts and Translations* (London, Hakluyt Society 1953); Alfred W. Pollard *English Miracle Plays, Moralities, and Interludes* (Oxford, Clarendon Press 1927); *The Golden Legend of Jacobus de Voragine* translated and adapted from the Latin by Granger Ryan and Helmut Ripperger (New York, Longmans, Green & Co 1941); Margaret R. Scherer *Marvels of Ancient Rome* (New York, Phaidon Press for Metropolitan Museum of Art 1955); and the *Dominican Missal* (London, Sheed & Ward 1932).

All biblical quotations are from the King James Version. The quotations from the Book of James, or Protoevangelium, are taken from the English translation in M. R. James *The Apocryphal New Testament* (London 1924).

Colophon: This book was designed by Bert Waggott. The text was set in the Printing Office of The New York Public Library; the manuscripts were photographed by Hugh J. Stern, New York; and printing by offset lithography was done at Meriden Gravure Company, Meriden, Conn. The binding was done by Russell-Rutter Company, Inc, New York.